PUNK!

THE CULTURE
IN PICTURES

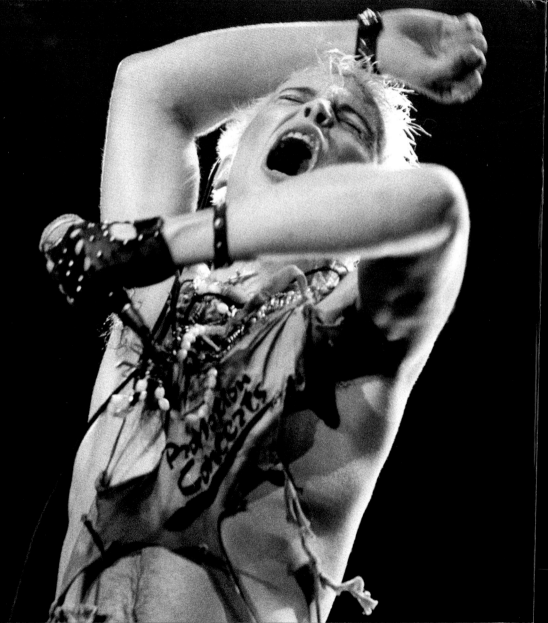

PUNK!

THE CULTURE IN PICTURES

mirrorpix

AMMONITE
PRESS

First published 2012 by
Ammonite Press
an imprint of AE Publications Ltd,
166 High Street, Lewes, East Sussex, BN7 1XU

Text © AE Publications Ltd, 2012
Images © Mirrorpix, 2012
Copyright © in the work AE Publications Ltd, 2012

ISBN 978-1-90770-829-9

British Cataloguing in Publication Data. A
catalogue record of this book is available from
the British Library.

Editor: Ian Penberthy
Series Editor: Richard Wiles
Picture research: Mirrorpix
Design: Gravemaker + Scott

Colour reproduction by GMC Reprographics
Printed and bound in China by C&C Offset Printing
Co. Ltd

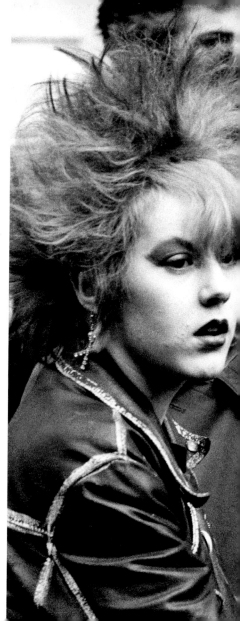

Idol talk
Page 2: Billy Idol (real name
William Broad) came to
prominence as a member of
the punk band Generation
X. Inspiration for his stage
name came from his school
days, when a teacher
described him as "idle".
11th September, 1984

Style points
Page 5: Hair that was
deliberately made to look
messy or dyed unnatural
colours, leather jackets,
studs and chains were all
part of the look adopted by
many punks.
3rd February, 1980

Shock tactics
Page 6: Punks reinforced
their anti-establishment
stance by creating a look
that was intended to shock
and unsettle. Some took
it to extremes with facial
piercings, make-up and
outlandish hair.
3rd February, 1980

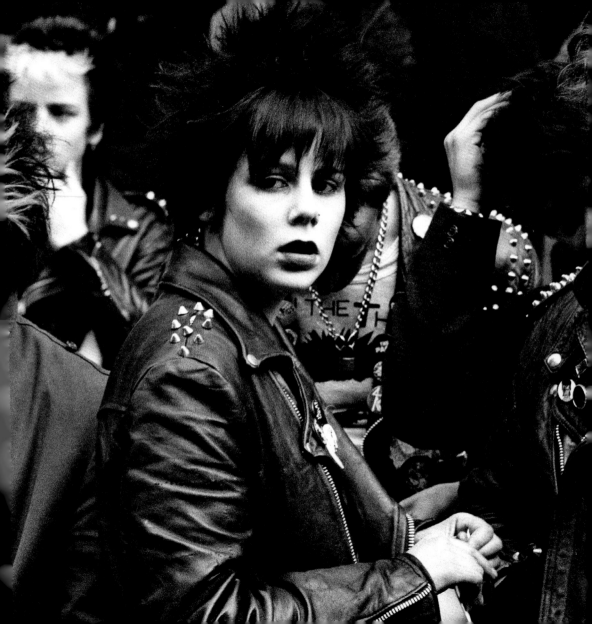

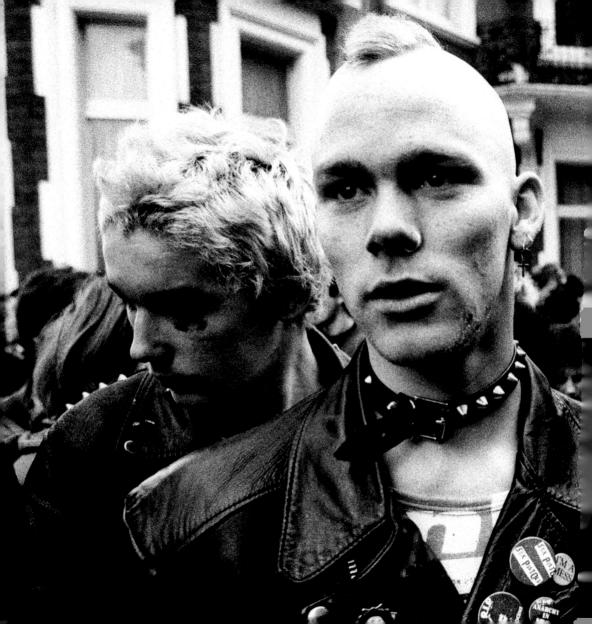

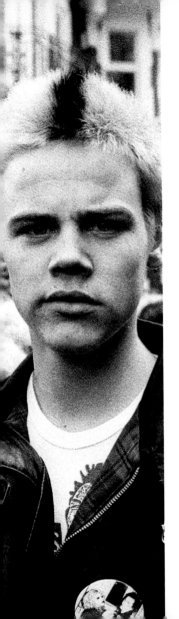

Introduction

Punk rock developed in the UK, the USA and Australia during the mid-1970s as a grass-roots reaction to the perceived excesses and pretensions of disco and mainstream rock. Punk bands played fast, hard-edged music, typically with basic instrumentation and often anti-establishment lyrics. Their short songs, backed by distorted guitars and loud drumming, drew heavily on 1960s garage rock and 1970s pub rock.

Bands such as The Ramones in New York, and The Sex Pistols and The Clash in London were the forerunners of this new musical movement, which would soon spread around the world. A punk sub-culture emerged, with an anti-establishment, anti-capitalist ethos, and characterised by distinctive clothing and accessories. The latter was designed to make a non-conformist, provocative statement, and included spiked and studded leather jackets and chokers, chain belts, heavy boots, ripped T-shirts (often bearing hand-written anarchic or offensive slogans and held together with safety pins), rubber and leather fetishwear, 'drainpipe' jeans and bondage trousers with their legs joined by long straps. Some punks made a point of wearing dirty, secondhand clothes as a stand against consumerism.

Many punks wore unkempt, short hair, but bright, unnatural colours became popular, as did styling the hair into startling shapes, including tall spikes and the famed Mohican, or Mohawk, crop. Tattoos and piercings complemented the look.

Much of punk fashion in the UK was inspired by Sex Pistols manager Malcolm McLaren and his partner, designer Vivienne Westwood. In addition, a group of Pistols fans from Kent, known as the Bromley Contingent, among them Susan Ballion (Siouxsie Sioux) and William Broad (Billy Idol), were early trend setters.

By the early 1980s, faster and more aggressive forms of punk rock, such as hardcore punk and Oi!, had become prominent. Musicians whose roots were in punk, or who had been inspired by it, also pursued other variations, leading to post-punk, New Wave and the alternative rock movement. By the turn of the century, pop punk had gone mainstream, bands such as America's Green Day and Britain's McFly achieving widespread popularity for the genre.

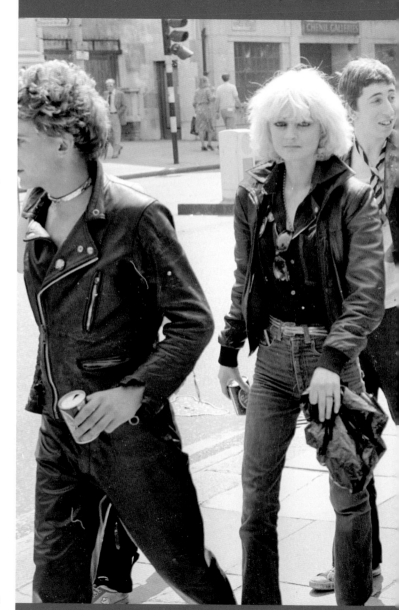

Looking out for teds
A group of punks on the
King's Road in London,
where clashes took place
with gangs of teddy boys.
30th July, 1977

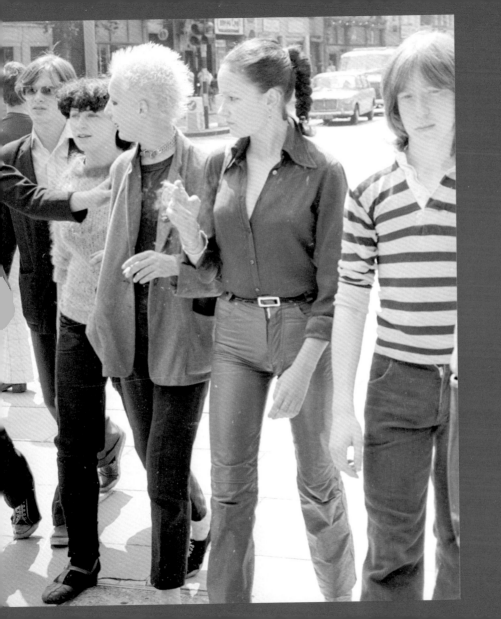

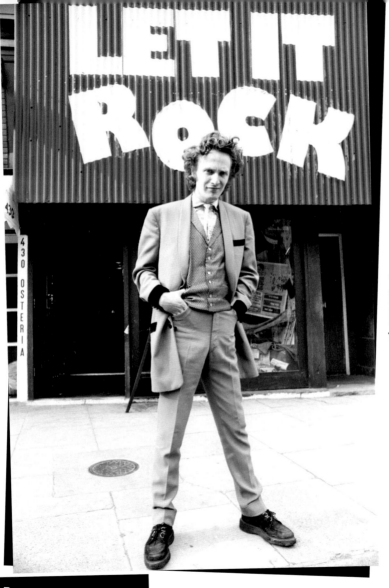

Once a teddy boy..
Manager of the
Sex Pistols, Malcolm
McLaren, in the days
before punk, when
he was a teddy boy
with a shop called Let
it Rock on the King's
Road, Chelsea.
14th March, 1972

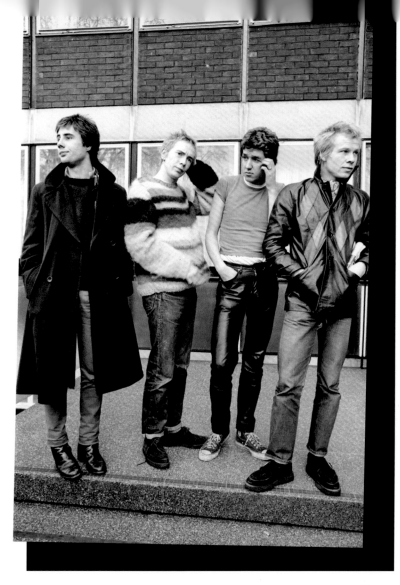

Boys in the band
Seminal punk band the Sex Pistols. L–R: Glen Matlock, Johnny Rotten, Steve Jones, Paul Cook.
2nd December, 1976

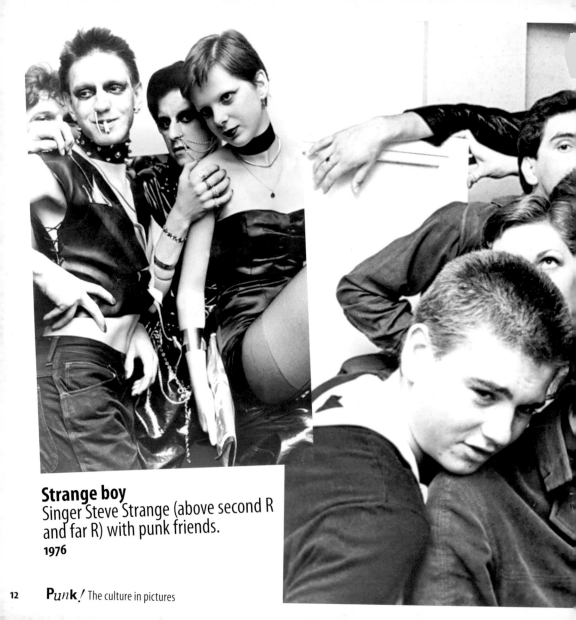

Strange boy
Singer Steve Strange (above second R and far R) with punk friends.
1976

Pu**nk**! The culture in pictures

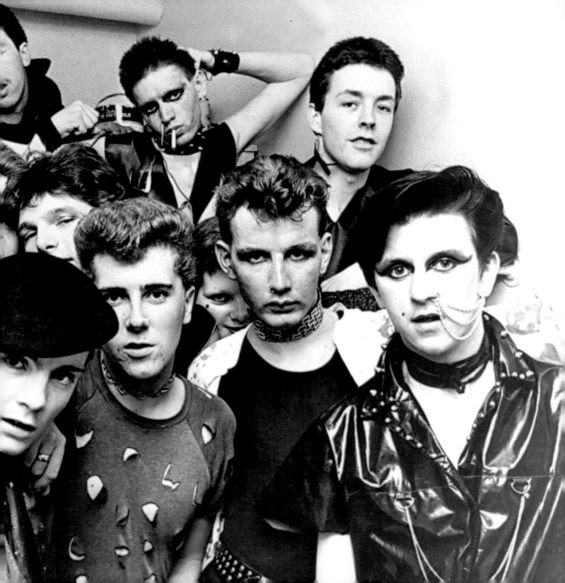

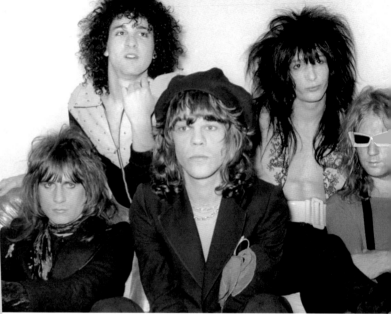

Doll faces
American glam rock band the New York Dolls were credited with having a major influence on the sound of early punk bands on both sides of the Atlantic.
11th November, 1973

The look
Left: Punk fashion defined by black jacket and bondage trousers; dyed black hair.
1977

The Godmother
Known as the 'Godmother of punk', American singer/songwriter Patti Smith was very influential on the New York scene.
10th May, 1975

Followers of fashion
Blazers, studded chokers, leather trousers and fishnets – a kaleidoscope of punk fashion.
1976

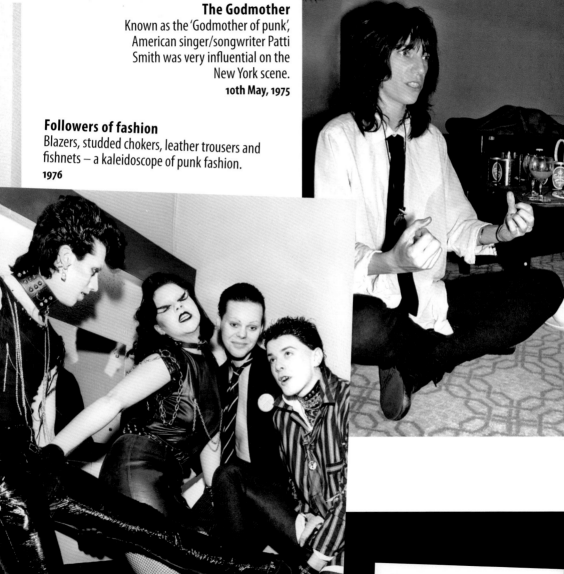

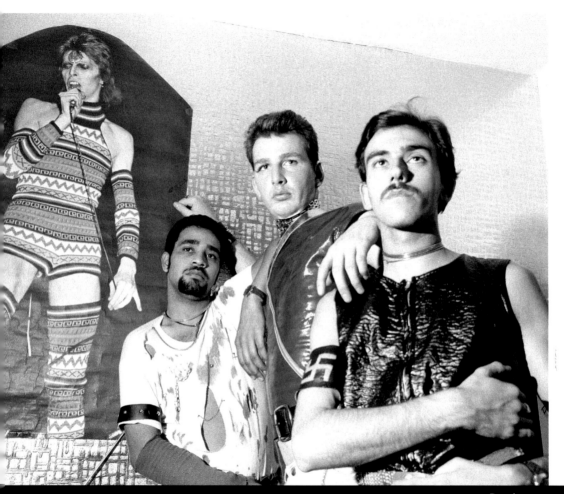

Bowie men

This punk trio clearly owe their allegiance to Ziggy Stardust. Swastika emblems were worn to shock rather than suggest support of extreme right-wing politics.

1976

Punk! The culture in pictures

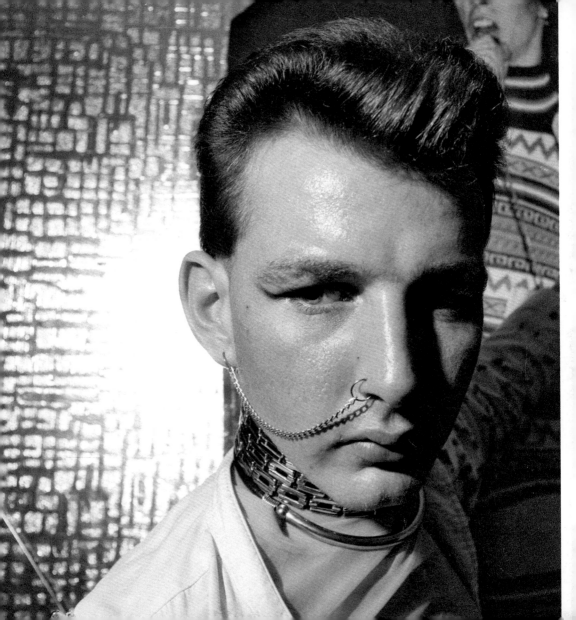

Going Global

Punks at The Global village disco. The essence of diy punk style: accessorise with safety pins and chains, or try a little face painting.

20th November, 1976

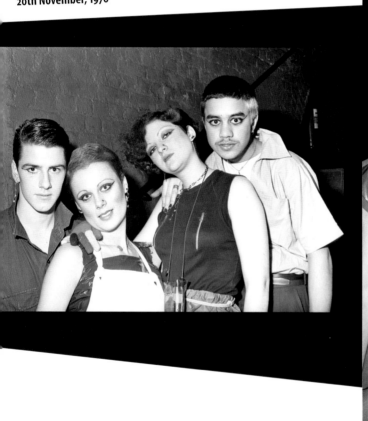

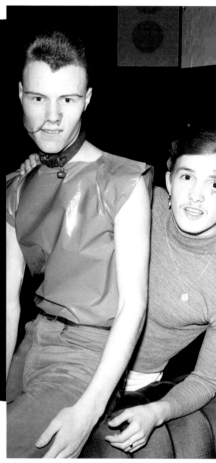

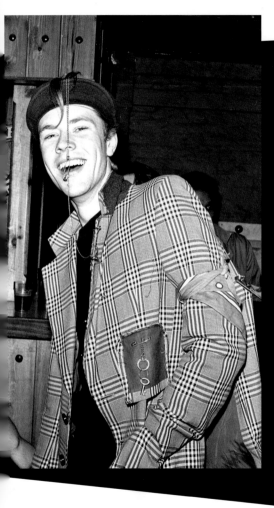

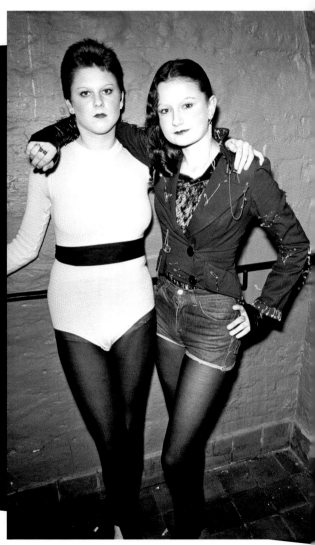

TV's Bill Grundy in rock outrage

?!★!

Daily Mirror

(B)RITAIN'S BIGGEST DAILY SALE

(Thursda)y, December 2, 1976 No. 22,658

THE FILTH AND THE FURY!

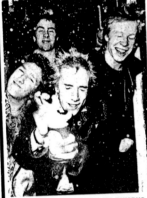

THE GROUP IN THE BIG TV RUMPUS
Johnny Rotten, leader of the Sex Pistols, opens a can of beer. Last night their language made TV viewers froth.

When the air turned blue . .

INTERVIEWER Bill Grundy introduced the Sex Pistols to viewers with the comment: "Words actually fail me about the next guests on tonight's show."

The group sang a number — and the amazing interview got under way.

GRUNDY: I am told you have received £40,000 from a record company. Doesn't that seem to be slightly opposed to an anti-materialistic way of life.

PISTOL: The more the merrier.

PISTOL: Yea, yea.

GRUNDY: Tell me more then.

PISTOL: F——ing spent it, didn't we.

GRUNDY: You are serious?

PISTOL: Mmmm.

GRUNDY: Beethoven, Mozart, Bach?

PISTOL: They're wonderful people.

GRUNDY: Are they?

PISTOL: Yes they really turn us on. They do.

GRUNDY: Suppose they turn other people on?

PISTOL (in a whisper): That's just their tough —.

GRUNDY: It's what?

PISTOL: Nothing—a rude word. Next question.

GRUNDY: No, no. What was the rude word?

PISTOL: S——.

GRUNDY: Was it really? Good heavens. What about you girls behind? Are you married or are you enjoying yourself?

GIRL: I've always wanted to meet you.

GRUNDY: Did you really? We'll meet afterwards, shall we?

PISTOL: You dirty old man.

GRUNDY: Go on, you've got a long time yet. You've got another five seconds. Say something outrageous.

PISTOL: You dirty bastard. You dirty bastard.

GRUNDY: Go on. Again.

PISTOL: You dirty f——er.

GRUNDY: What?

PISTOL: What a f——ing rotter.

GRUNDY: Well, that's it for to-night . . . I'll be seeing you soon. I hope I'm not seeing YOU again. Goodnight.

A POP group shocked millions of viewers last night with the filthiest language heard on British television.

The Sex Pistols, leaders of the new "punk rock" cult, hurled a string of four letter obscenities at interviewer Bill Grundy on Thames TV's family teatime programme "Today."

The Thames switchboard was flooded with protests.

Nearly 200 angry viewers telephoned the Mirror. One man was so furious that he kicked in the screen of his £380 colour TV.

Grundy was immediately carpeted by his boss and will apologise in tonight's programme.

Shocker

A Thames spokesman said: "Because the programme was live, we could not foresee the language which would be used. We apologise to all viewers.

The show, screened at peak children's viewing time, turned into a shocker when Grundy asked about £40,000 that the Sex Pistols received

By STUART GREIG, MICHAEL McCARTHY and JOHN PEACOCK

from their record company.

One member of the group said: "F——ing spent it, didn't we?"

Then when Grundy asked about people who preferred Beethoven, Mozart and Bach, another Sex Pistol remarked: "That's just their tough s——."

Later Grundy told the group: "Say something outrageous."

A punk rocker replied: "You dirty sod. You dirty bastard." "Go on. Again," said Grundy.

"You dirty f——er?"

"What?"

Uproar as viewers jam phones

"What a f——ing rotter." As the Thames's switchboard became jammed, viewers rang the Mirror to voice their complaints.

Lorry driver James Holmes, 47, was outraged that his eight-year-old son Lee heard the swearing . . . and kicked in the screen of his TV.

"It blew up and I was knocked backwards," he said. "But I was so angry and disgusted with this filth that I took a swing with my boot.

"I can swear as well as anyone, but I don't want this sort of muck coming into my house at teatime."

Mr. Holmes, of Beechfield Walk, Waltham Abbey, Essex, added: "I am not a violent person, but I would like to have got hold of Grundy.

"He should be sacked for encouraging this sort of disgusting behaviour."

WHO ARE THESE PUNKS? PAGE NINE

Front-page news
The front page of the *Daily Mirror* from 2nd December, 1976, describing the outrage by TV viewers following an interview of the Sex Pistols and other punks by Bill Grundy on an early-evening chat show. The punks, goaded by a drunken Grundy, spat out a series of obscenities. As a result, Grundy was suspended for two weeks and the programme was axed two months later.
2nd December, 1976

20 **Punk!** The culture in pictures

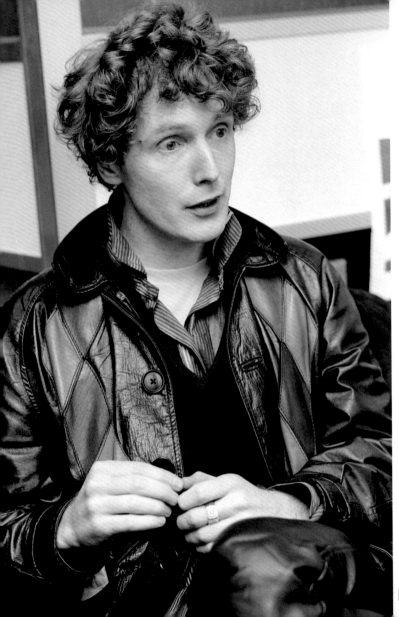

Malcolm in the middle

Malcolm McLaren, manager of the Sex Pistols, at a press conference in Manchester to defend the band against growing criticism of their recent television appearance on the *Today* programme.
2nd December, 1976

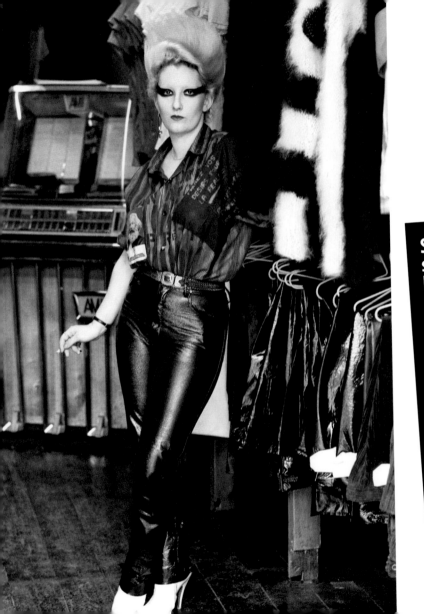

Sex and the single girl
Pamela Rooke, known as Jordan, at Malcolm McLaren's shop, Sex, on The King's Road, where she worked.
5th December, 1976

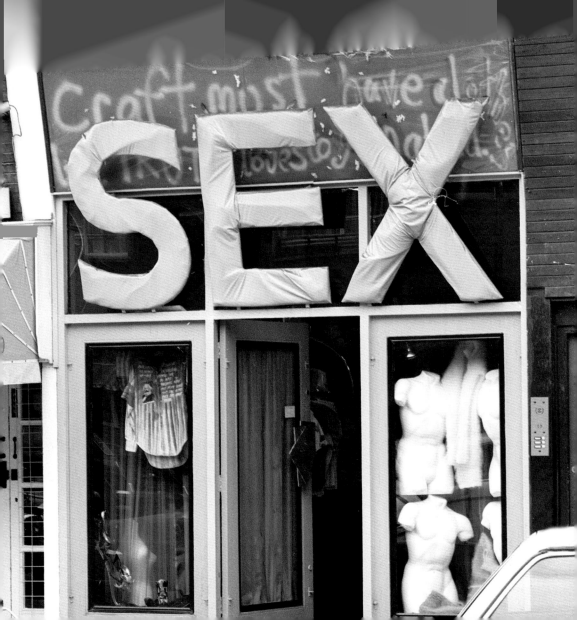

Punk emporium
Sex offered punk fashion, much of it designed by Vivienne Westwood.
5th December, 1976

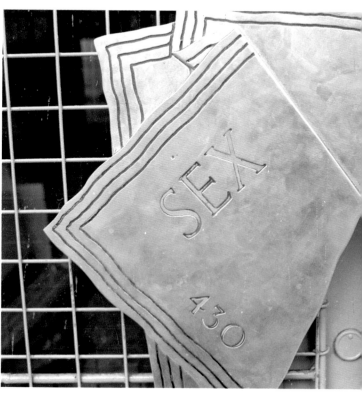

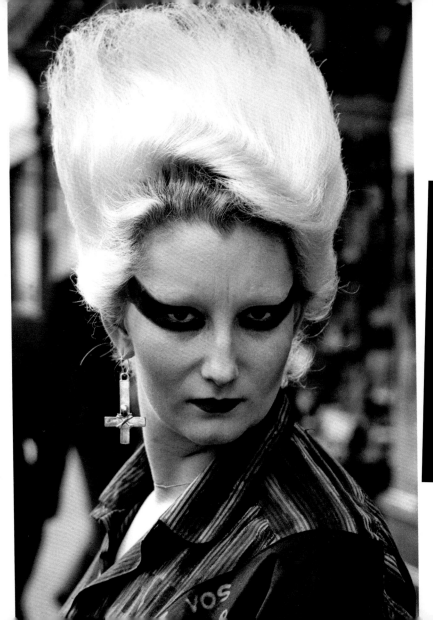

Striking a pose
Jordan always cut a striking figure. She subsequently became Adam and The Ants' manager, although only for a short time.
5th December, 1976

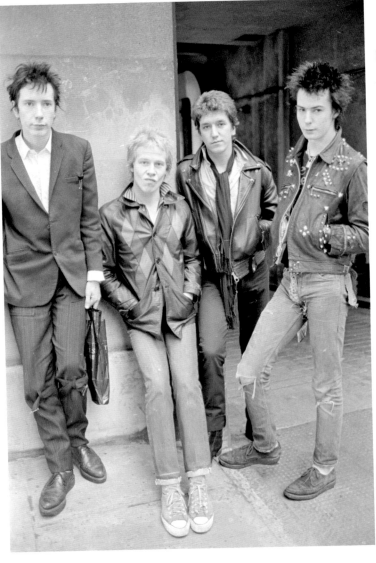

New boy
After Glen Matlock left the Sex Pistols, following differences with Johnny Rotten, Sid Vicious (R) joined the line-up.
1st July, 1977

Ripping yarn
Ripped clothing was a staple of punk fashion. A run-in with the law added kudos to the bad-boy, anti-establishment image.
6th August, 1977

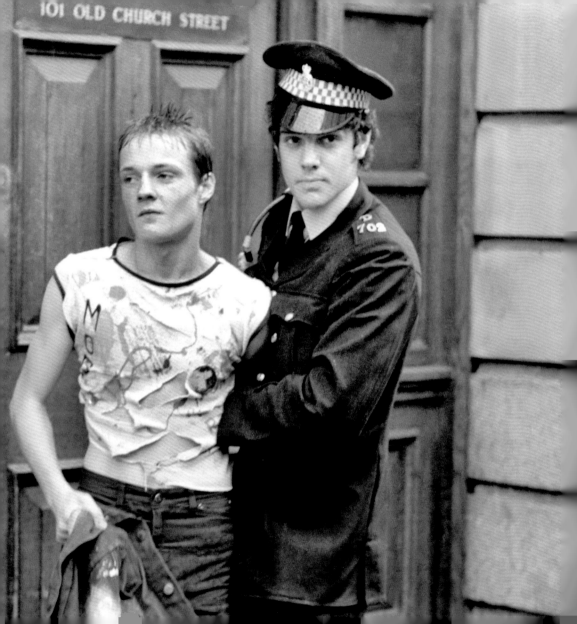

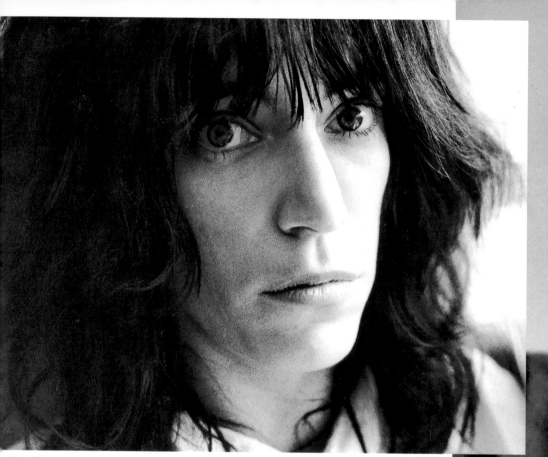

Punk poet
Patti Smith's work was an
amalgamation of rock and
poetry. She was also an
artist and rock journalist.
11th May, 1976

Keeping his shirt on
American singer Iggy Pop,
whose work with The
Stooges in the early 1970s
helped lay the foundations
for the punk movement.
1st March, 1977

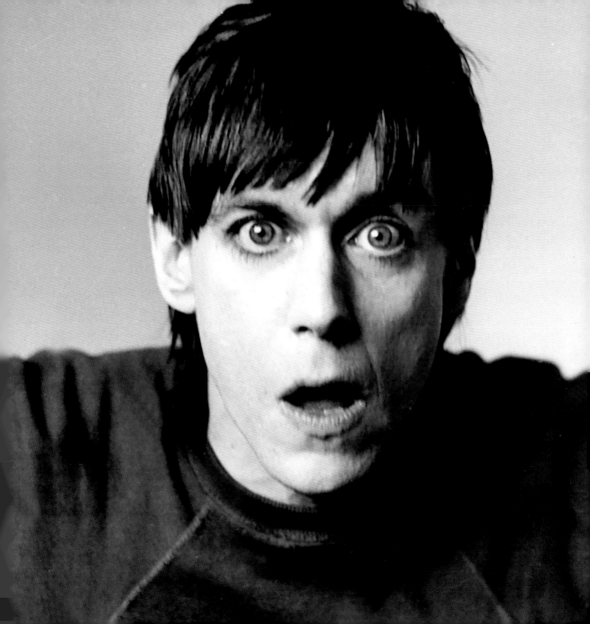

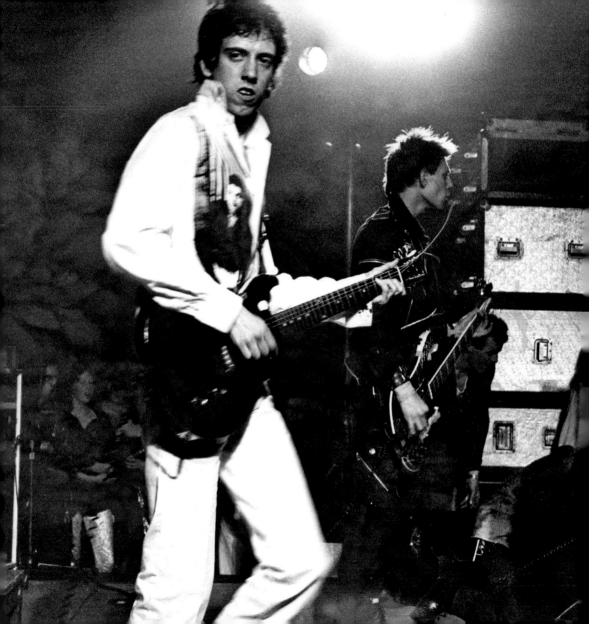

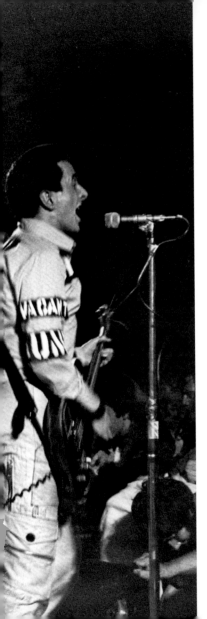

Clash bash
The Clash play a gig at the Students Union, Newcastle Upon Tyne: Mick Jones on guitar (L), Paul Simonon on bass (second L), Joe Strummer on guitar and vocals (C), and Nicky 'Topper' Headon on drums.
20th May, 1977

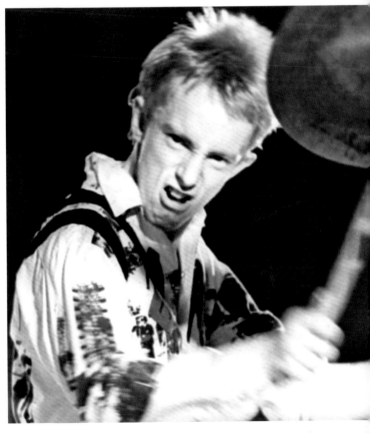

US pioneers
Blondie, fronted by singer Debbie Harry, were major contributors to the early American punk and New Wave scenes. They were regulars at the CBGB club in New York.
1st April, 1977

UK pioneers
The Damned, fronted by Dave Vanian (L), were the first UK punk band to release a single and an album, and to have a record in the UK charts.
10th April, 1977

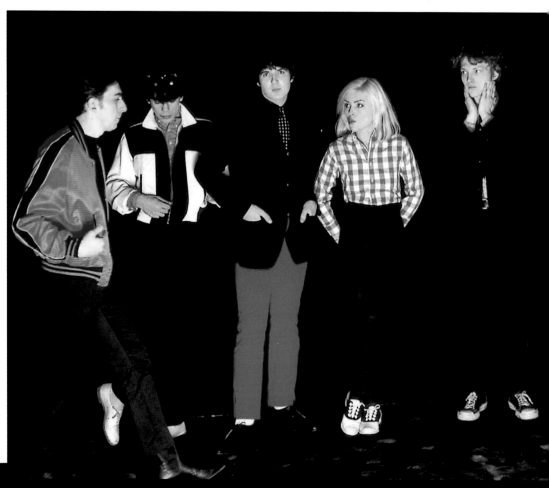

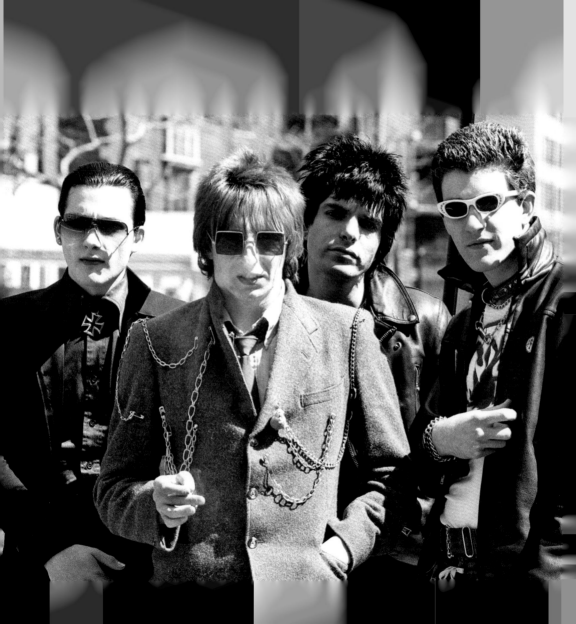

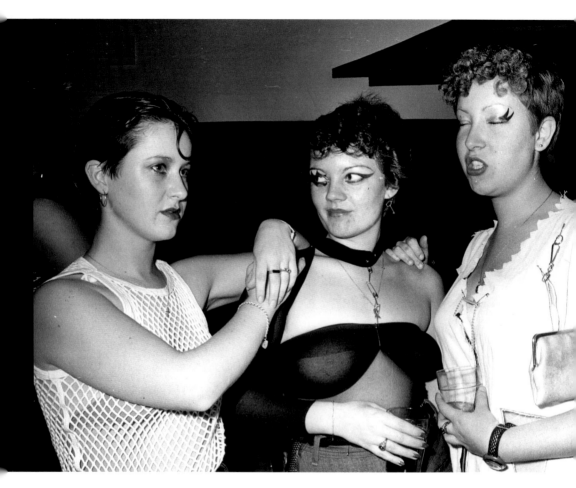

Fashionistas
Punk fashion was wide ranging; even a string vest could be put to good use.
1st December, 1976

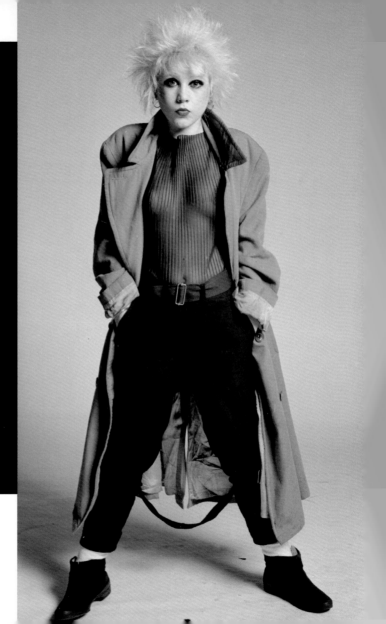

Debbie does punk
Debbie Wilson, an assistant in Malcolm McLaren's shop, Sex, wears an oversize coat, chiffon top and bondage trousers. Wilson adopted the name Debbie Juvenile and was a member of the 'Bromley Contingent', a group of Sex Pistols fans who were major innovators of early punk fashion.
December, 1977

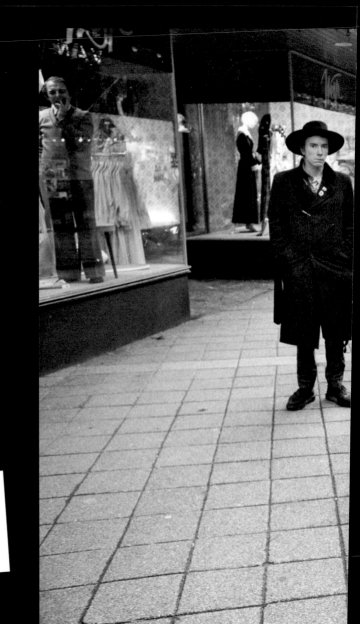

Camera shy?
The Sex Pistols play to the camera while on tour in the Netherlands.
December, 1977

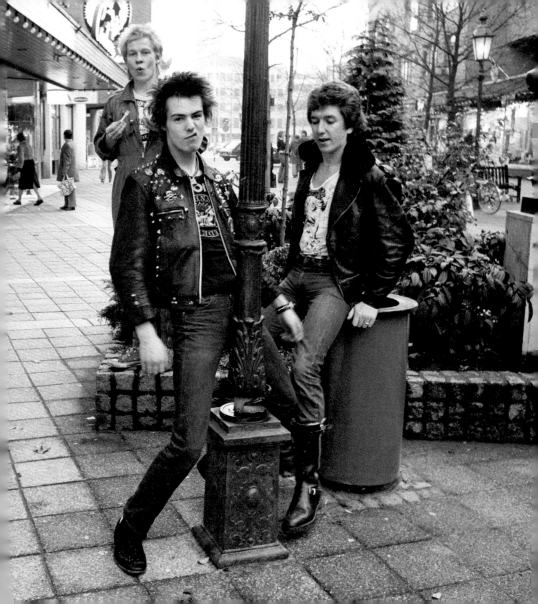

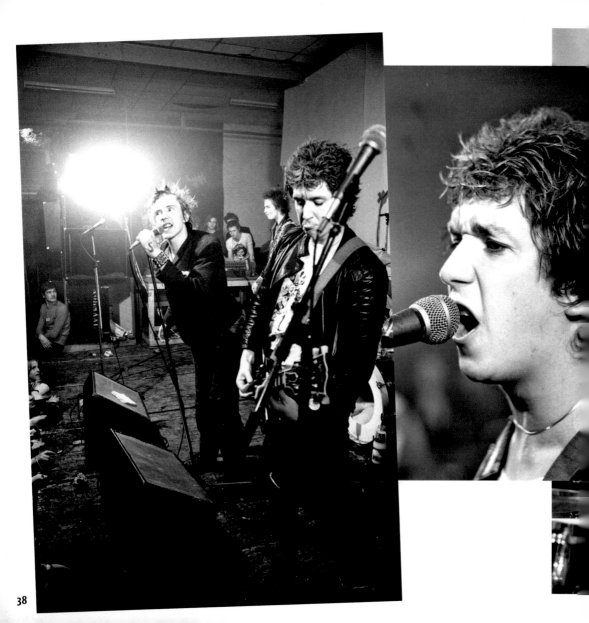

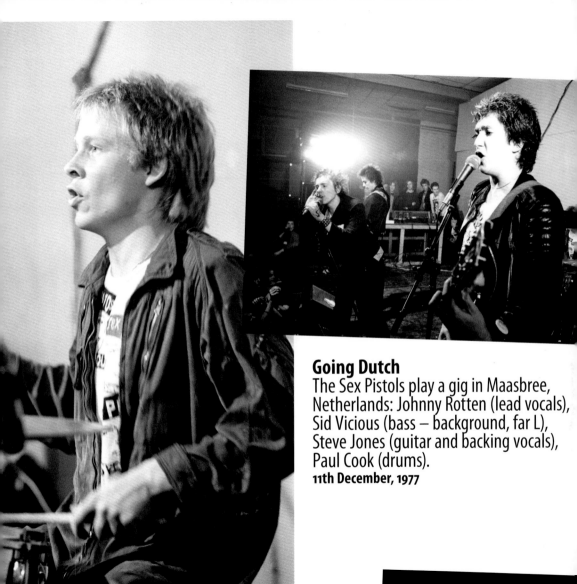

Going Dutch
The Sex Pistols play a gig in Maasbree,
Netherlands: Johnny Rotten (lead vocals),
Sid Vicious (bass – background, far L),
Steve Jones (guitar and backing vocals),
Paul Cook (drums).
11th December, 1977

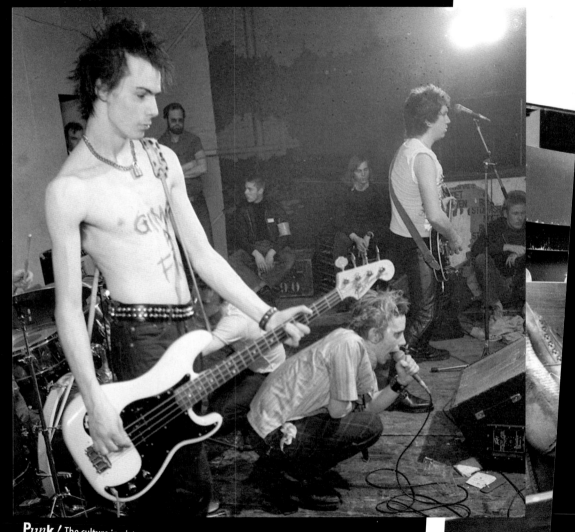

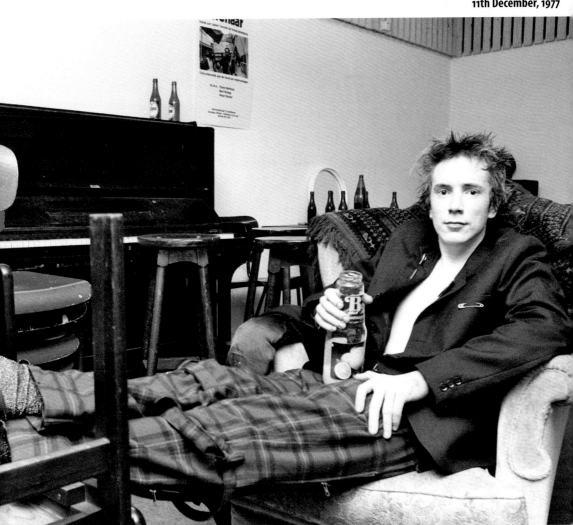

Taking it easy

Johnny Rotten (real name John Lydon) relaxes after the Maasbree gig.

11th December, 1977

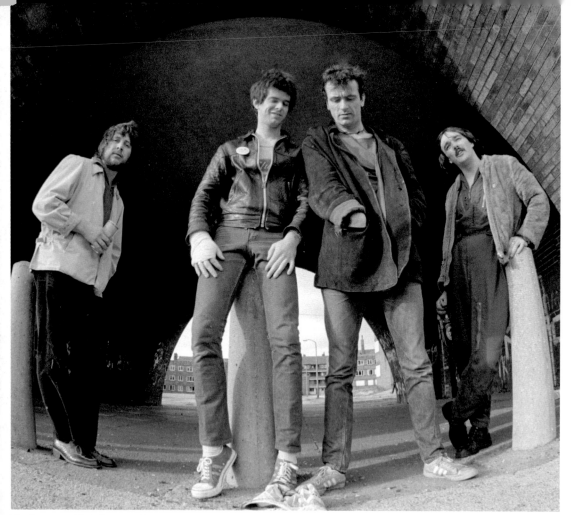

Underneath the arches

The Stranglers in Manchester for a gig. L–R: Jet Black, Jean-Jacques Burnel, Hugh Cornwell, Dave Greenfield.

8th June, 1977

Punk! The culture in pictures

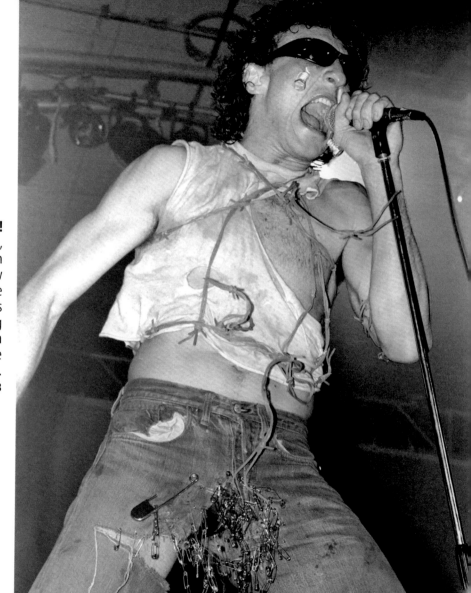

Rip it up!
Fee Waybill, singer with American New Wave band The Tubes, adopts punk clothing and pins for a ripping time on stage.
29th April, 1978

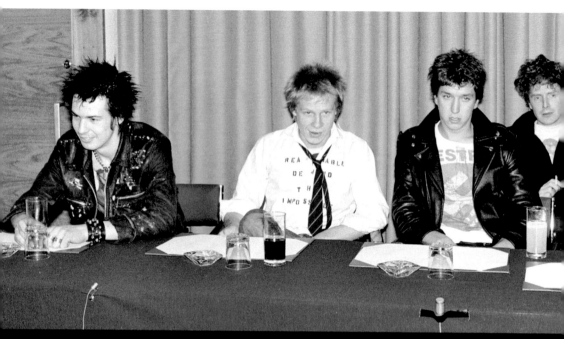

Bad boys

After signing to A&M Records, having been dropped by EMI, the Sex Pistols gave a press conference at the company's offices. Intoxicated, they caused mayhem. Their antics over the following days caused further consternation among the company's executives, who broke the band's contract six days later. Some 25,000 copies of their new single, God Save The Queen, were destroyed before being released. Subsequently, they signed with Virgin, who released the single.

10th March, 1977

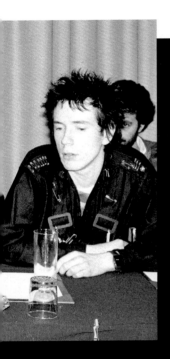

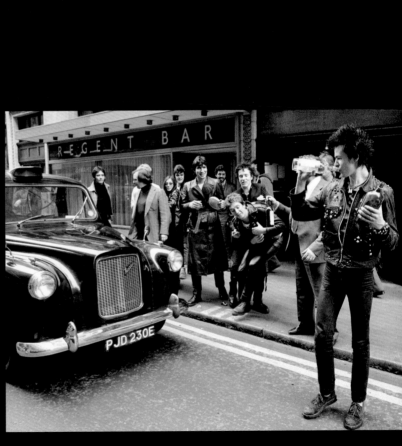

Court appearance

Right: Joe Strummer (L) and Nicky Headon of The Clash, after appearing in court at Morpeth, charged with the theft of a pillowcase from the Holiday Inn hotel in Seaton Burn, North Tyneside. They were fined £100.

13th June, 1977

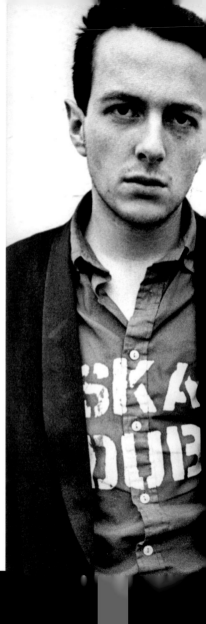

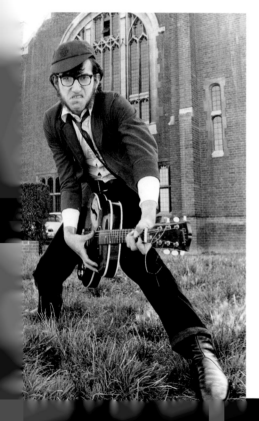

Low strummer

Left: Julian Isaacs, aka Auntie Pus, the punk balladier, demonstrates his playing style.

20th September, 1977

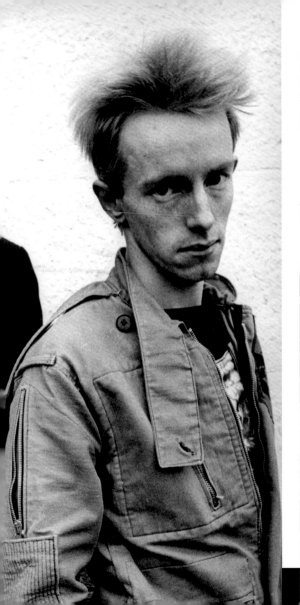

Strolling
A punk couple out for a stroll.
21st September, 1977.

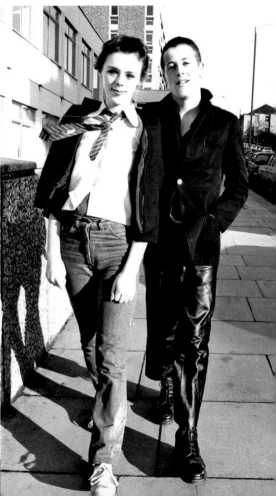

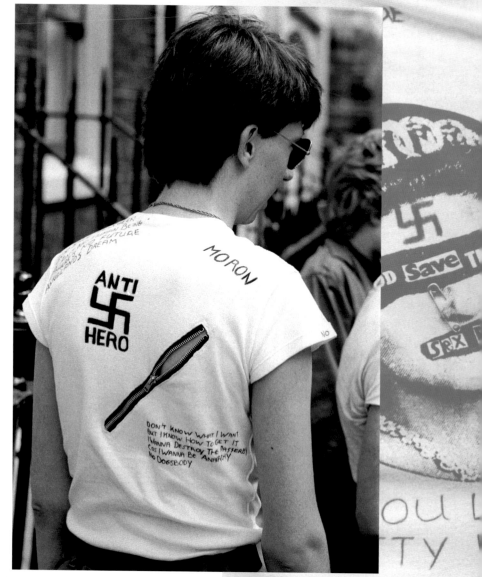

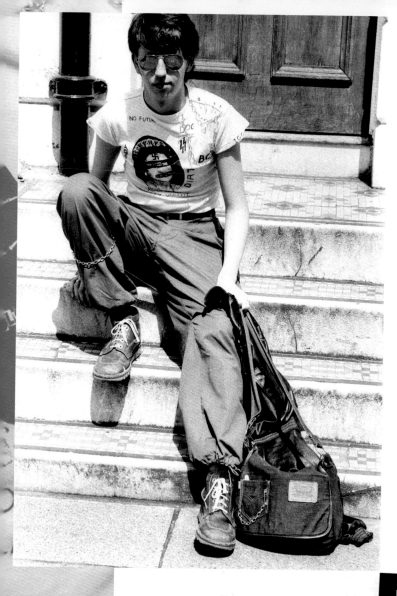

Done to a T
Punk wearing a Sex
Pistols T-shirt with
a design based on the
sleeve of their single,
God Save the Queen.
8th July, 1977

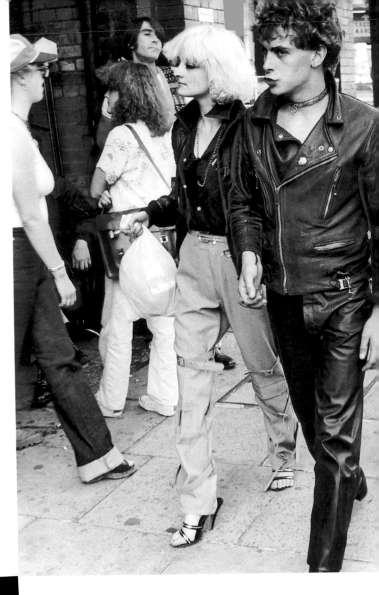

Gone shopping
A fashionably dressed punk couple go shopping on the King's Road in London.
30th July, 1977

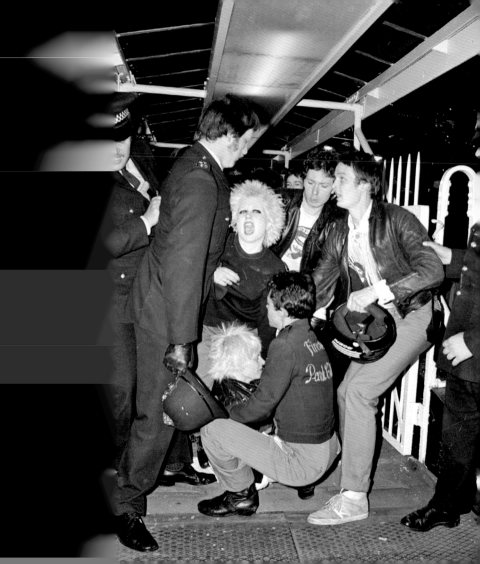

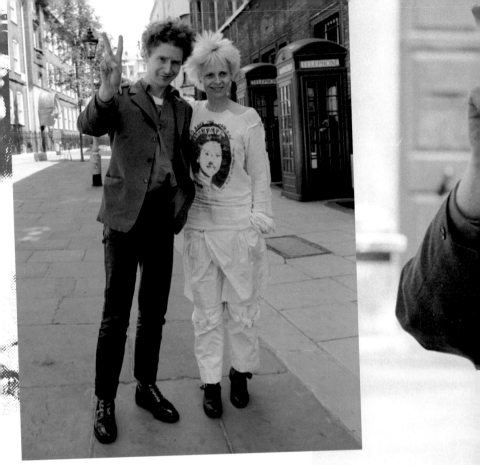

fighters

ols manager Malcolm McLaren and fashion designer Vivienne
od outside Bow Street Magistrates' Court, where they had been
ed on bail for fighting during the Sex Pistols' riverboat party.

, 1977

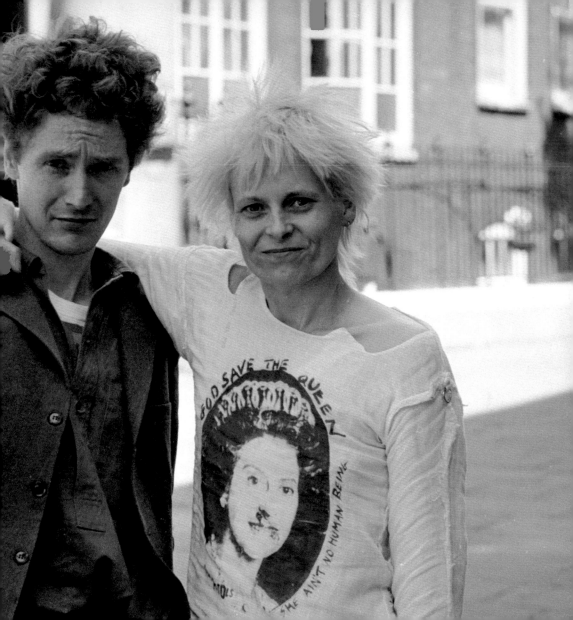

Splashing out
Punks and teddy
boys taunt each
other outside a pub
in London.
1st August, 1977

Spoiling for a fight
Punks gather in the
King's Road, London,
ready for another clash
with teddy boys.
30th July, 1977

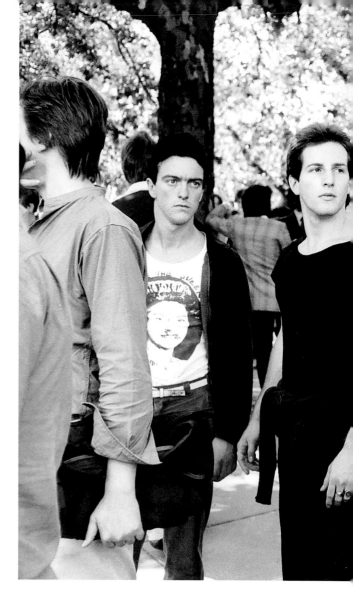

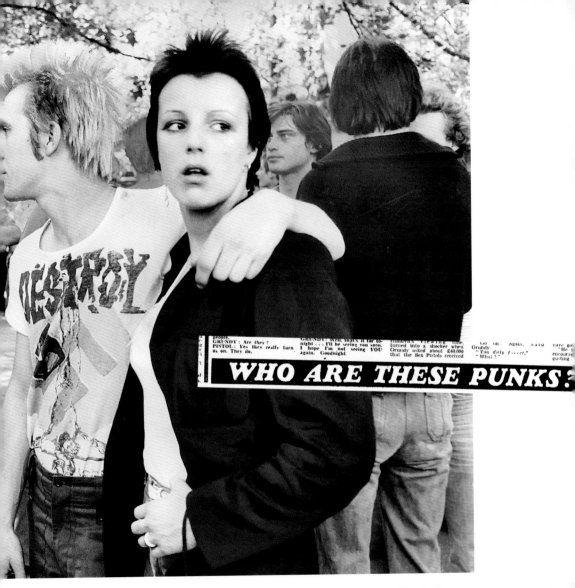

GRUNDY: Are they?
PISTOL: Yes they really turn us on. They do.

GRUNDY: Well, that's it for to-night . . . I'll be seeing you soon. I hope I'm not seeing YOU again. Goodnight.

children's viewing time, turned into a shocker when Grundy asked about £40,000 that the Sex Pistols received

Go on. Again, said Grundy.
"You dirty f----er."
"What?"

WHO ARE THESE PUNKS?

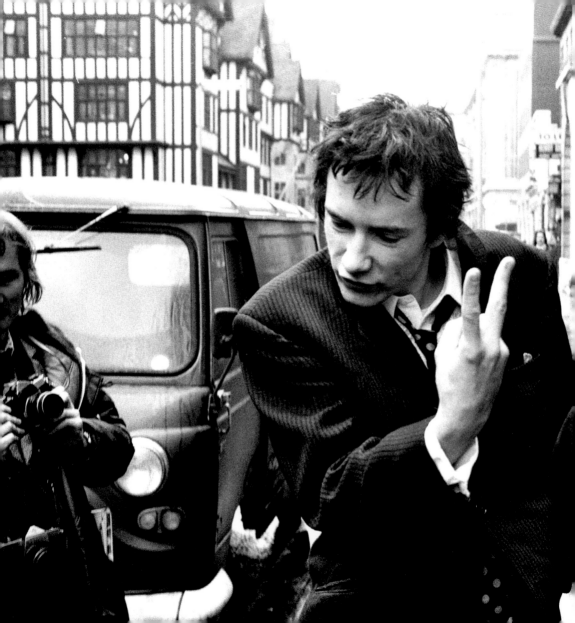

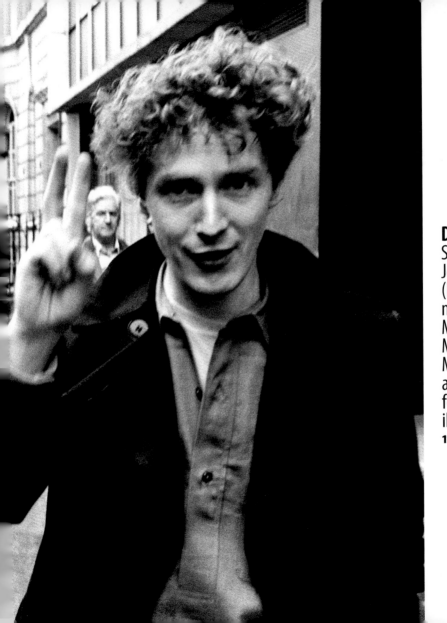

Defiant gestures
Sex Pistols singer
Johnny Rotten
(L), with band
manager Malcolm
McLaren, leaves
Malborough Street
Magistrates' Court
after being fined
for possessing an
illegal drug.
11th March, 1977

Street fashion

Civil servant Peter King (L) displays a more refined, less-aggressive type of punk fashion. The individual on the right is more confrontational, with chains, studs and leather fingerless gloves.

1977

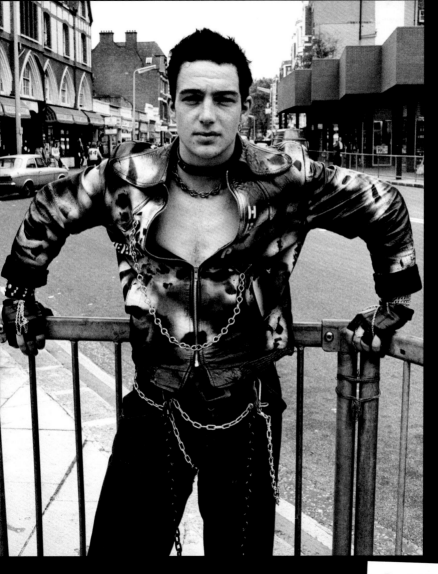

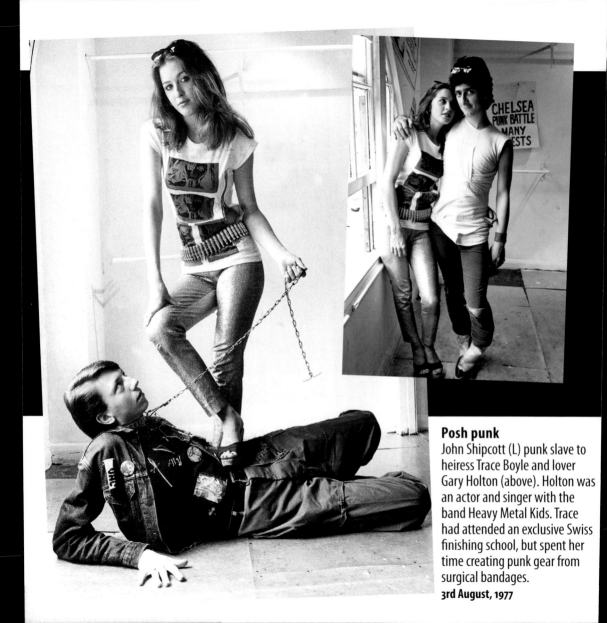

Posh punk

John Shipcott (L) punk slave to heiress Trace Boyle and lover Gary Holton (above). Holton was an actor and singer with the band Heavy Metal Kids. Trace had attended an exclusive Swiss finishing school, but spent her time creating punk gear from surgical bandages.

3rd August, 1977

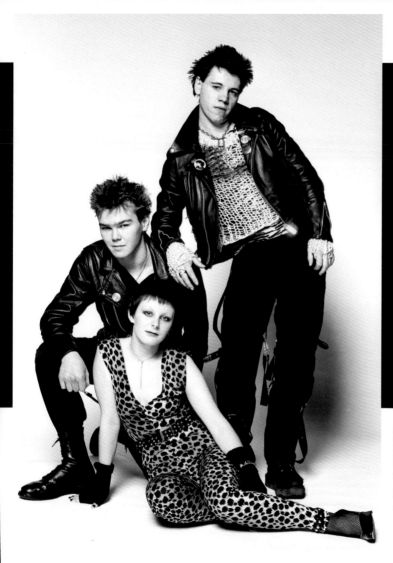

Animal skins
Leather jackets and
leopard-print materials
were staples of punk
street fashion.
18th December, 1977

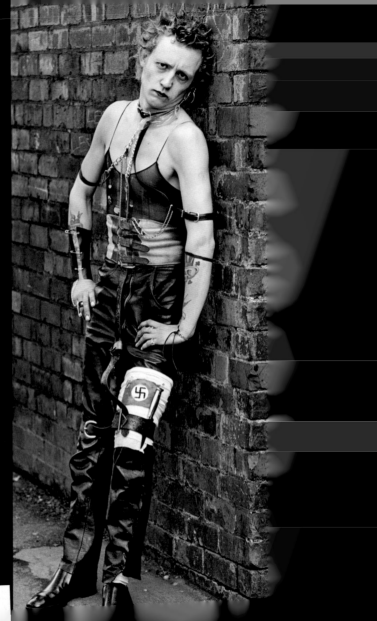

Change of direction
Accountancy student Ian Hodge, from Woolwich in south London, who gave up studying to follow the punk lifestyle. His outfit combines some interesting items, including a gentleman's abdominal support.
12th June, 1977

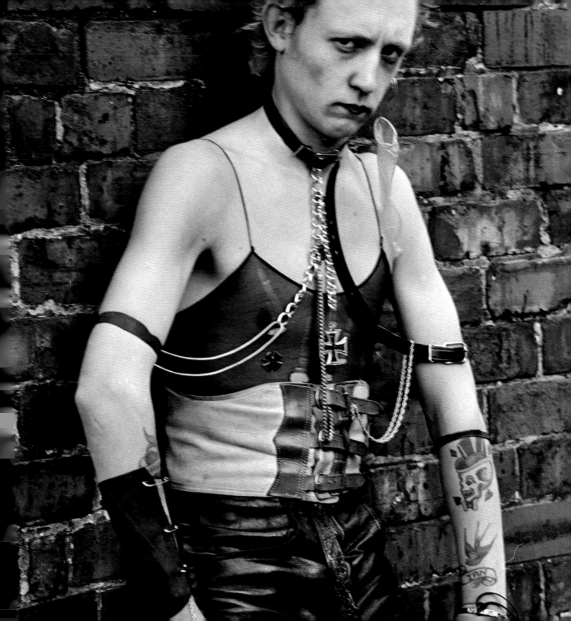

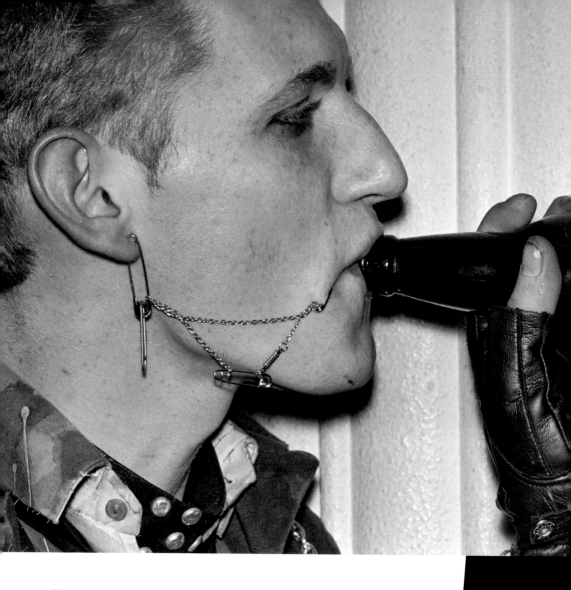

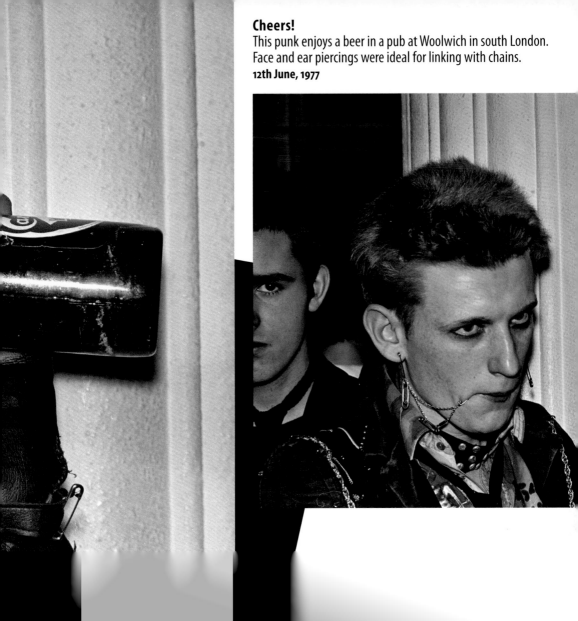

Cheers!
This punk enjoys a beer in a pub at Woolwich in south London. Face and ear piercings were ideal for linking with chains.
12th June, 1977

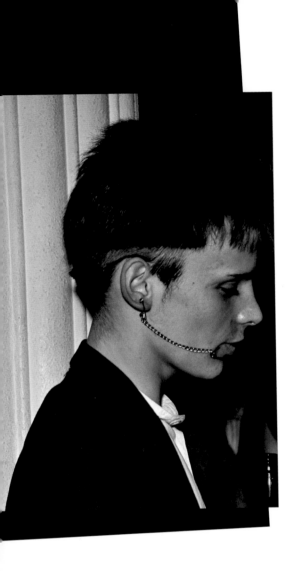

Pinned up

As well as adorning clothes, the safety pin could be used with piercings to good effect – perhaps to link a chain from ear to mouth (L) or from ear to septum (R). Piercings may have been done professionally or self-inflicted.

12th June, 1977

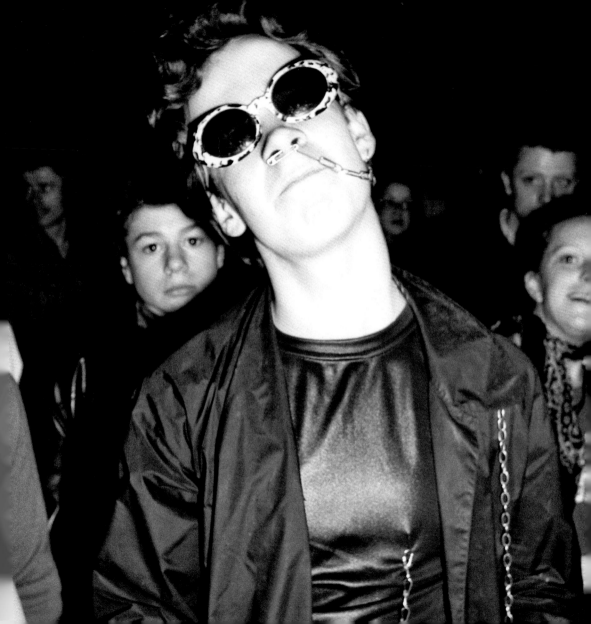

Gone, gone, gone
Adoring fans watch the The Stranglers
performing in Manchester
on a warm summer night.
9th June, 1977

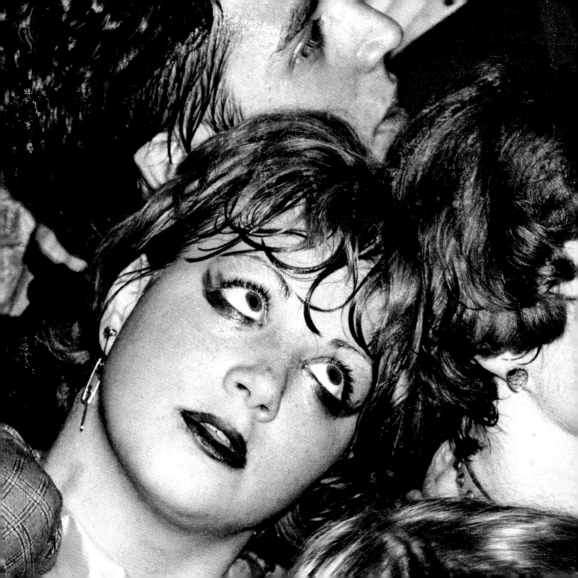

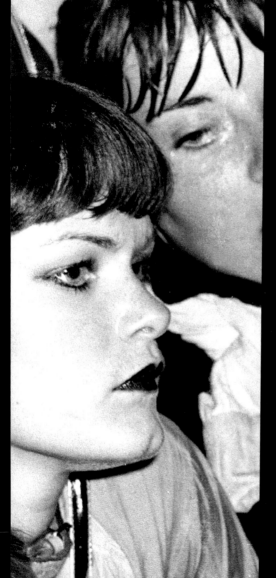

Punks plus
The age and musical skills of The Stranglers
set them apart from the run of punk bands;
even so, the band members considered
themselves part of the punk movement.
9th June, 1977

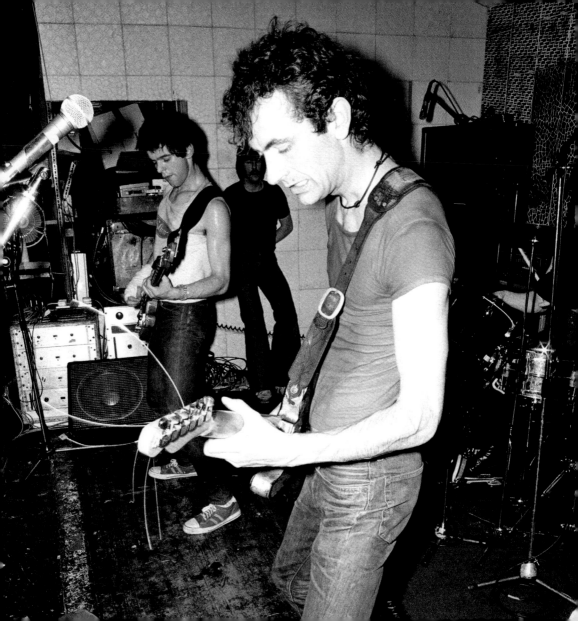

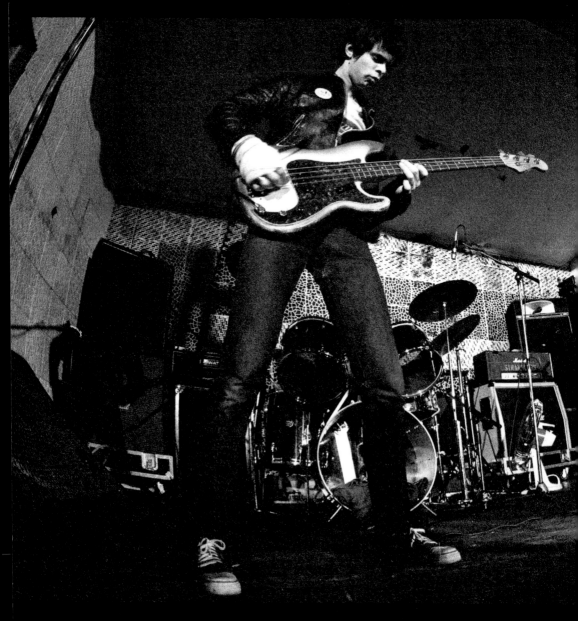

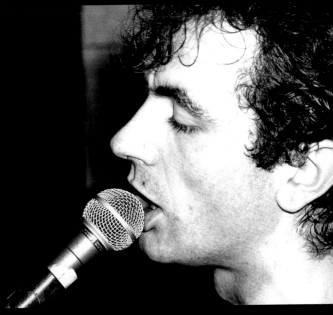

Front men
Left: Jean-Jacques Burnel (L) and Hugh Cornwell
front The Stranglers during their Manchester gig.
9th June, 1977

Singin' the blues?
Cornwell had been a blues musician before
becoming a co-founder of The Stranglers in
Guildford, Surrey, in 1974
9th June, 197

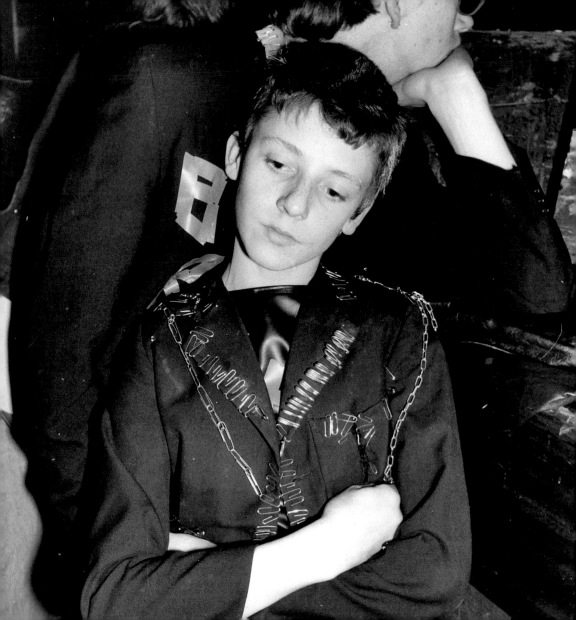

Clip art
Facing page: If safety pins were in short supply, paper clips would do.
12th June, 1977

Tragic case
Sid Vicious (real name John Ritchie), bass player with the Sex Pistols. Vicious would die of a drug overdose in New York, after being released on bail for the murder of his girlfriend, Nancy Spungen.
29th March, 1977

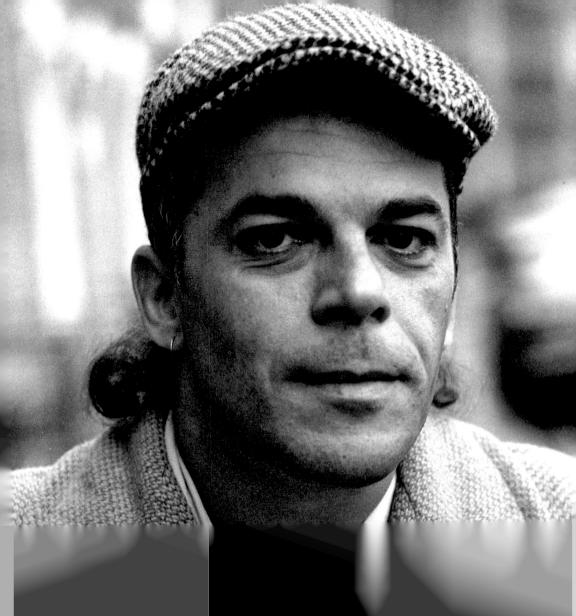

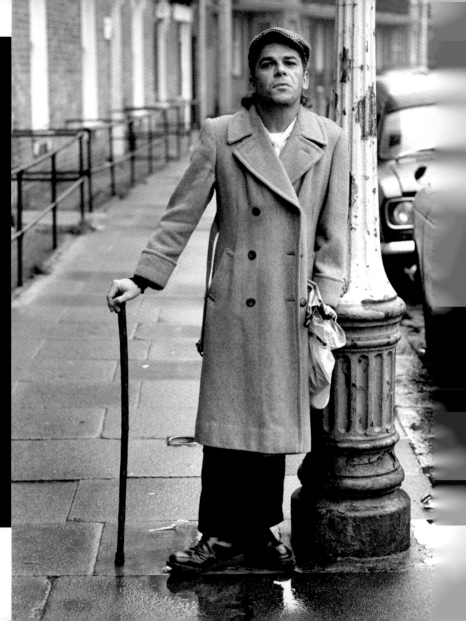

Punk predecessor

Although not a punk musician himself, Ian Dury, best known for his work in the late 1970s with his band, The Blockheads, was considered as being protopunk for the influence his work had on early punk musicians.

8th December, 1977

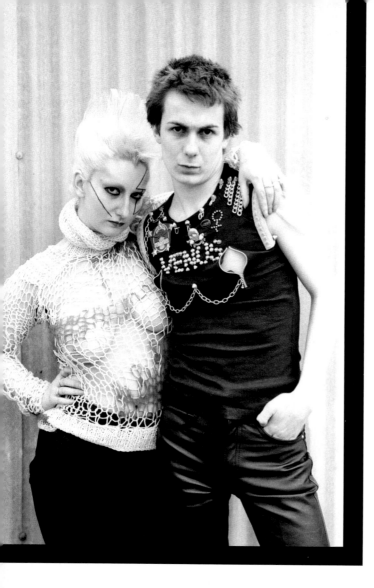

Pu**nk***!* The culture in pictures

After a fashion
Punk icon Jordan and friend take part in a fashion shoot.
1977

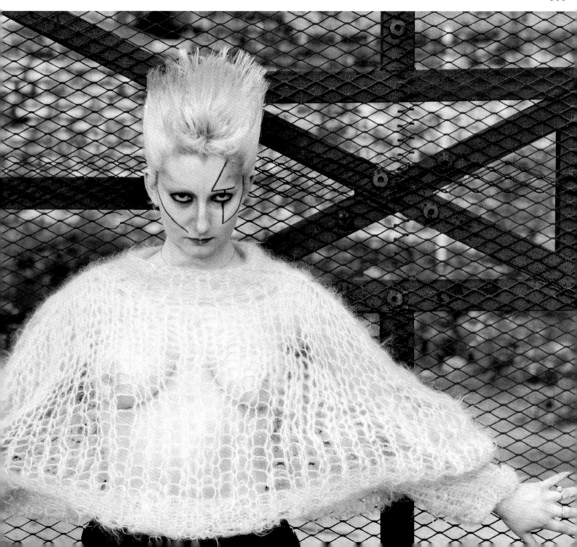

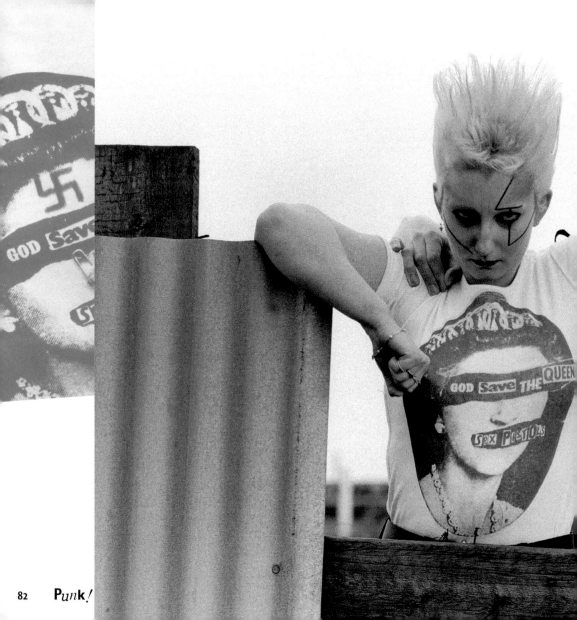

Punk!

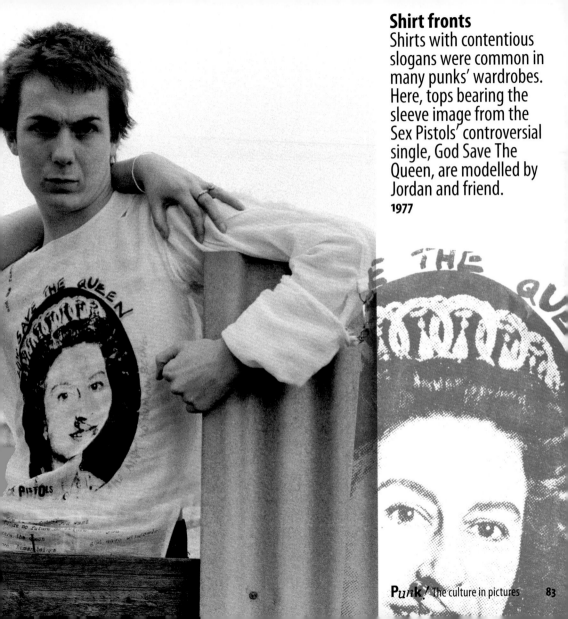

Shirt fronts
Shirts with contentious slogans were common in many punks' wardrobes. Here, tops bearing the sleeve image from the Sex Pistols' controversial single, God Save The Queen, are modelled by Jordan and friend.
1977

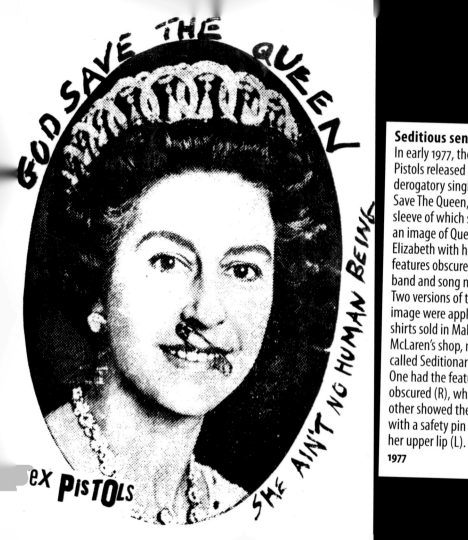

GOD SAVE THE QUEEN

eX PISTOLS

SHE AIN'T NO HUMAN BEING

Seditious sentiment
In early 1977, the Sex Pistols released the derogatory single God Save The Queen, the sleeve of which showed an image of Queen Elizabeth with her features obscured by the band and song names. Two versions of this image were applied to shirts sold in Malcolm McLaren's shop, now called Seditionaries. One had the features obscured (R), while the other showed the Queen with a safety pin through her upper lip (L).
1977

NO FUTURE DOG

DIRT

ROY

GOD Save THE
Sex Pistols

YOU LOOK
PRETTY VACANT

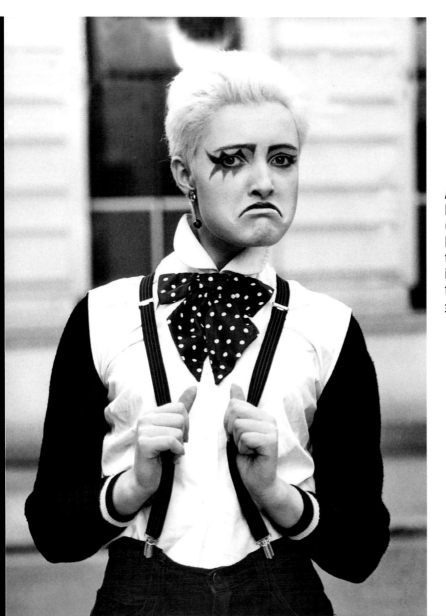

A girl named Sioux
Left: Siouxsie Sioux (real name Susan Ballion) is considered to be one of the most influential singers of the rock era.
3rd December, 1976

Punk roots
Right: Although they would evolve musically, Siouxsie and The Banshees, fronted by Siouxsie Sioux, had their roots in the punk movement, having been inspired originally by the Sex Pistols.
1st October, 1978

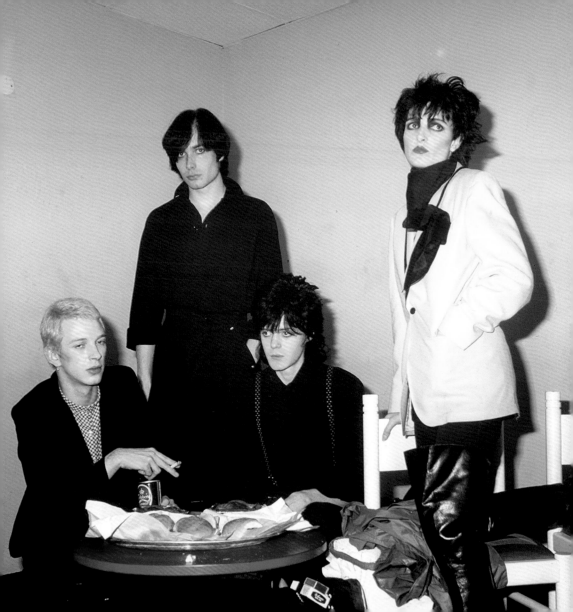

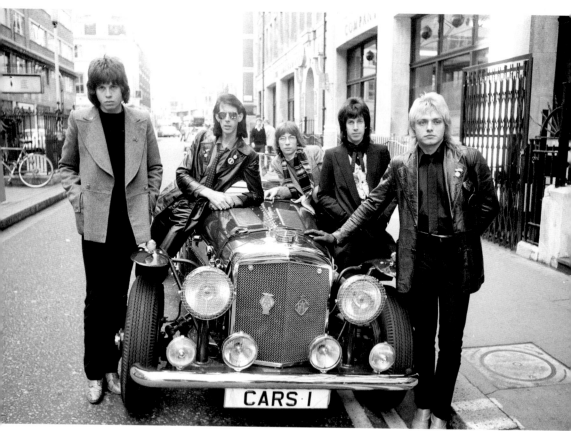

Moving on
American New Wave band The Cars in London: L–R: Elliot Easton, Ric Ocasek, Greg Hawkes, David Robinson and Ben Orr. New Wave developed from punk rock, relying on much of its sound and spirit, and its predeliction for short, punchy songs.
16th November, 1978

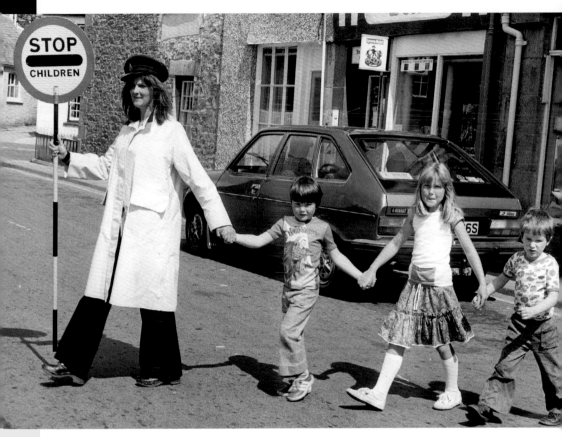

Punk mum
Viva Hamnel, a 'lollipop lady' in Callington, Cornwall, also was a singer with her son's punk band.
1978

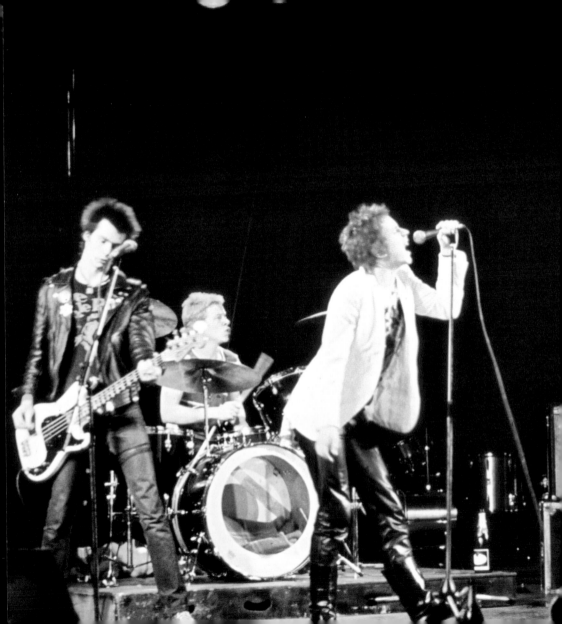

Pistols performance
The Sex Pistols on stage.
1978

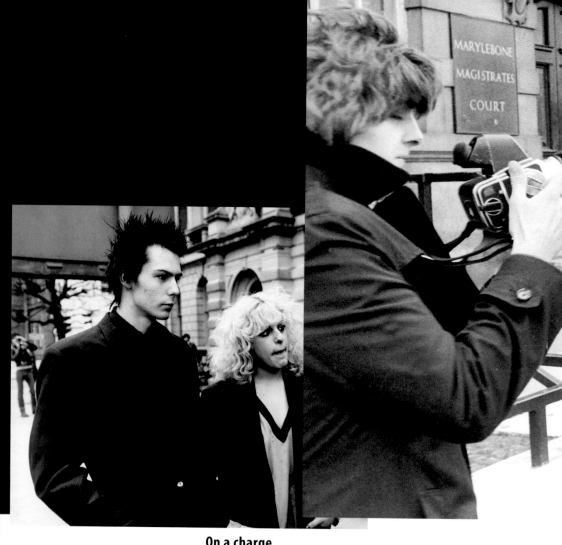

On a charge
Sex Pistols bassist Sid Vicious with girlfriend Nancy Spungen at
Marylebone Magistrates' Court on a drugs charge.
8th February, 1978

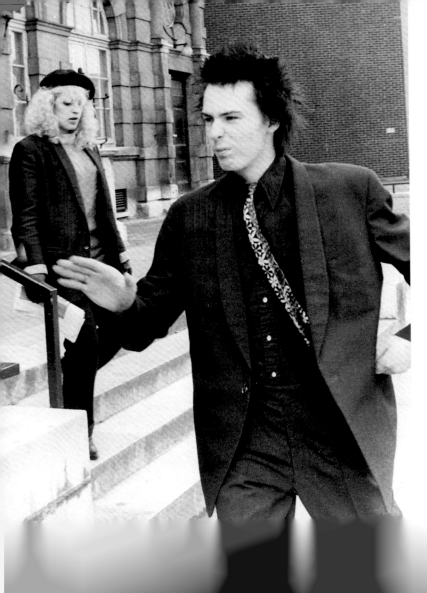

Lashing out
Sid Vicious
reacts to being
photographed
at Marylebone
Magistrates'
Court, while Nancy
Spungen descends
the steps behind.
12th May, 1978

Supporting Sid

Gary Howe and Jane Hall model Sid Vicious T-shirts, sold by Malcolm McLaren through his Seditionaries shop in London to help support the Sex Pistols bassist, who had been arrested and charged with the murder of his girlfriend, Nancy Spungen, in New York.

October, 1978

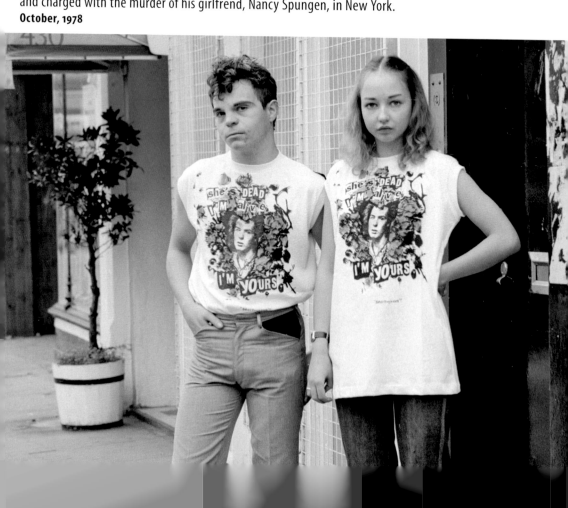

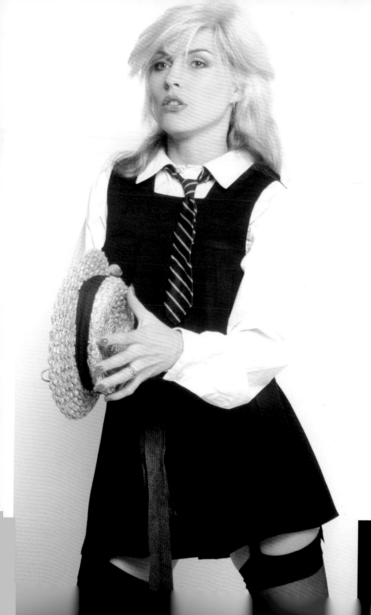

Blonde having fun
Debbie Harry's blonde-bombshell looks made her an acceptable face of the punk movement.
August, 1978

Wailing Banshees

Siouxsie and The Banshees on stage.
Sioux had formed the band with
bassist Steven Severin. Although
initially a punk band, they quickly
evolved to the post-punk genre and
became highly regarded for their
musical audacity.

1978

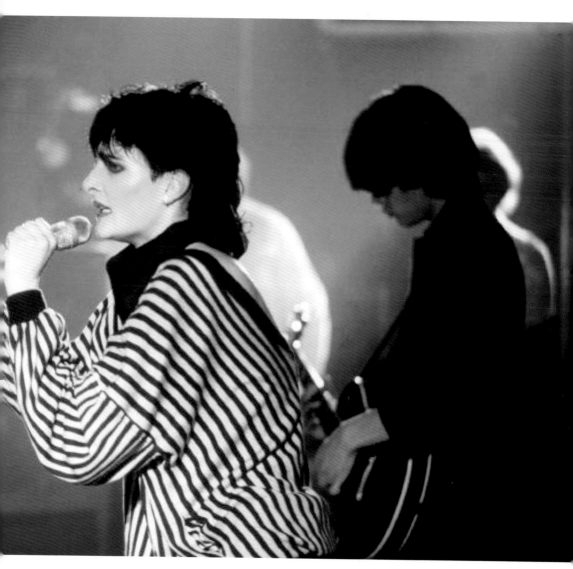

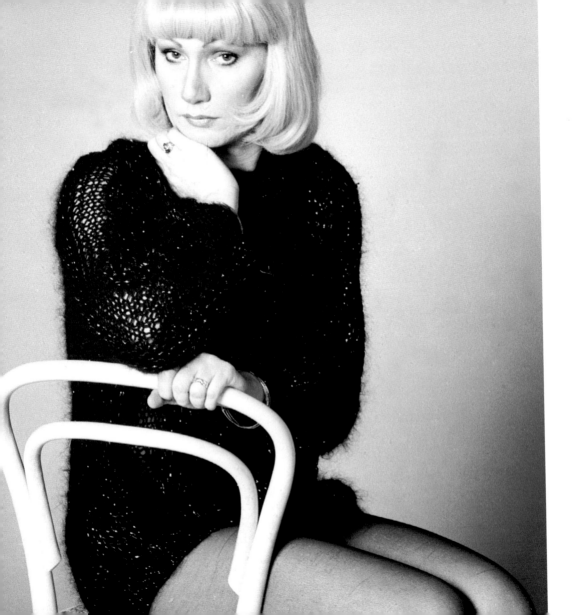

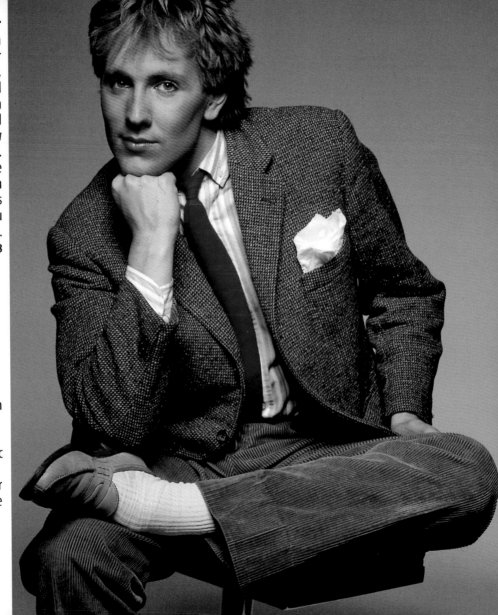

Punk poseur
Right: Belgian punk singer [P]lastic Bertrand, [wh]o was credited as the artist on [th]e international hit single *Ça Plane Pour Moi*. In reality, the song had been recorded by its composer, Lou Deprijck.
1978

[Tr]ans punk
[Le]ft: American [tra]nssexual [pu]nk singer and [ac]tress Wayne [(la]ter Jayne) [Co]unty, who [m]oved to London [in] 1977 and [for]med a band [cal]led the Electric [Ch]airs. She was [re]nowned for her [ou]trageous stage [an]tics and such [so]ngs as *Are You [M]an Enough To [Be] A Woman?*
[5]th September, [19]78

Regular contributor

Caroline Coon, political activist, artist and journalist, who became a regular on the punk scene, writing for the music press. She also created artworks for bands such as The Clash, whom she managed for a while.
7th March, 1978

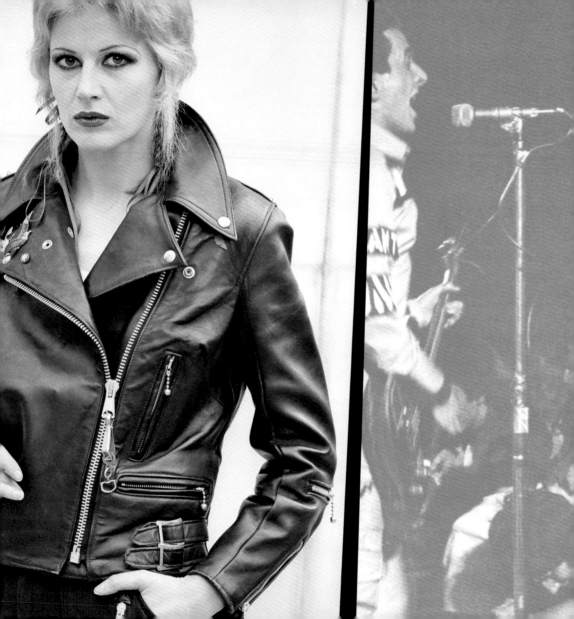

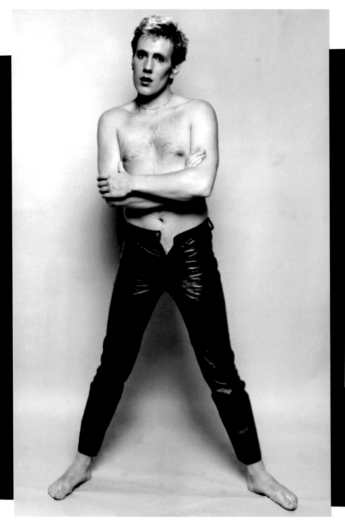

Right: Actress Jenn
Runacre arrives fo
the premiere of Dere
Jarman's punk film
Jubilee, at The New
Gate cinema, London
Runacre played a
time travelling Queen
Elizabeth I in the film
22nd February, 1978

Pogo Plastic
Plastic Bertrand, the Belgian punk who would
sing while pogo dancing.
June, 1978

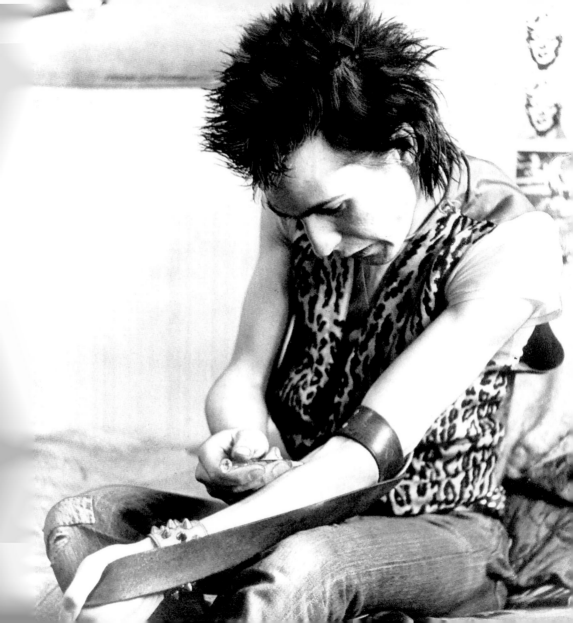

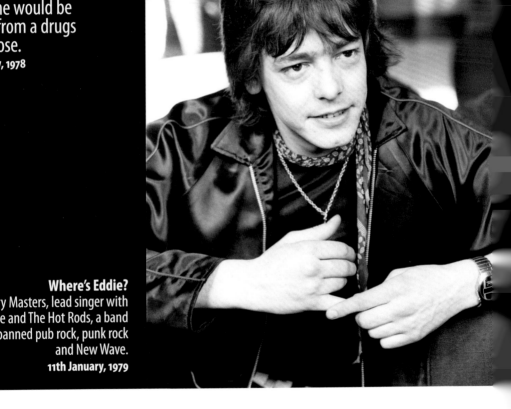

Road to ruin
Left: Sid Vicious injects himself with heroin. Within the year, he would be dead from a drugs overdose.
15th May, 1978

Where's Eddie?
Barry Masters, lead singer with Eddie and The Hot Rods, a band that spanned pub rock, punk rock and New Wave.
11th January, 1979

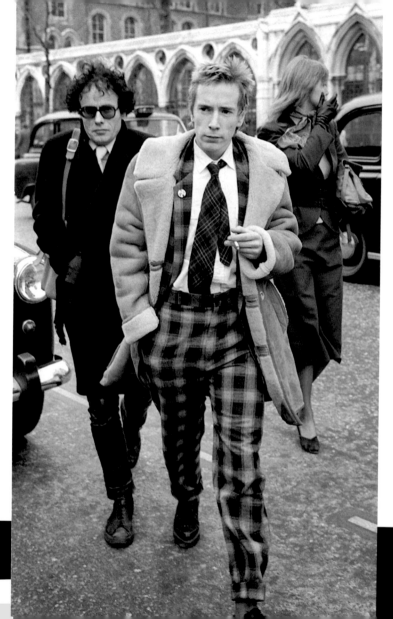

Rotten luck
Left: Johnny Rotten arrives at court on a drugs charge.
8th February, 1979

Fair cop?
Right: A police dog handler detains a pun wearing a 'Sid Vicious RIP' T-shirt.
27th August, 1979

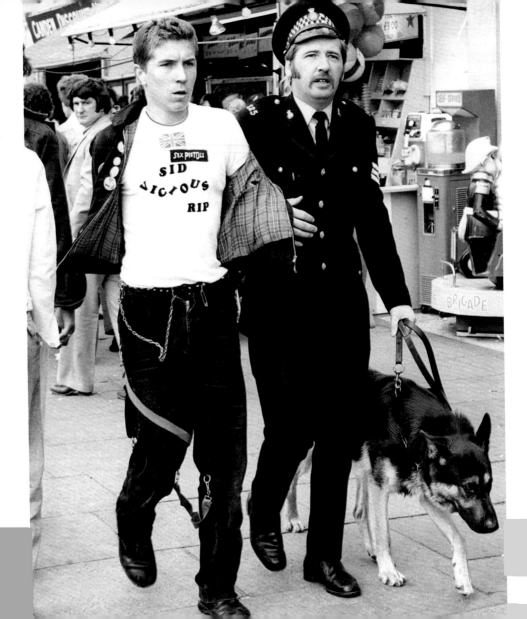

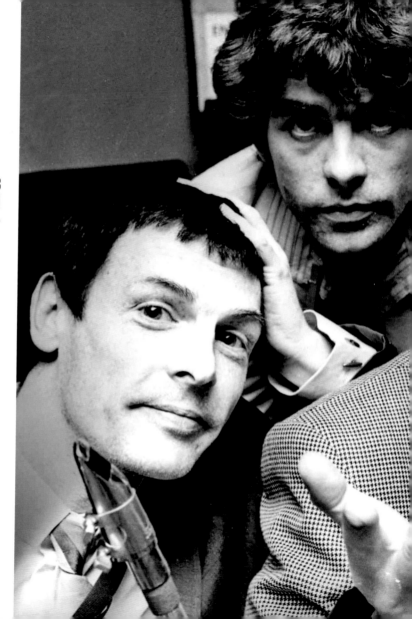

Forerunners
Protopunk band
Ian Dury and The
Blockheads in
Cardiff for a gig.
L–R: Davey Payne,
John Turnbull,
Ian Dury and
Norman Watt-Roy.
1978

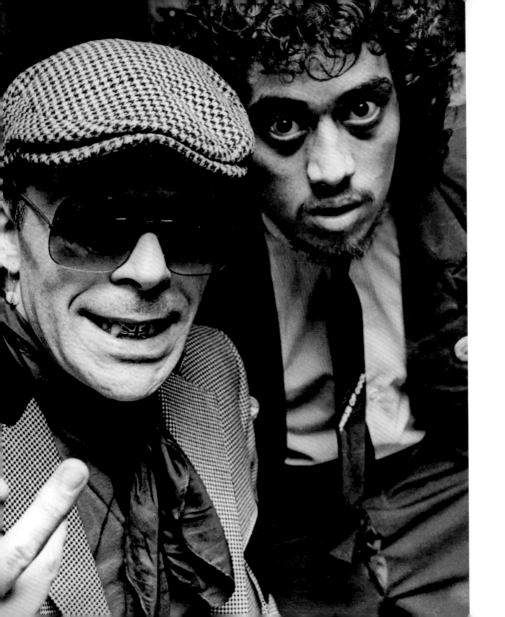

Coffin fit

Punk singer and actress Toyah Willcox. While attempting to establish her musical career, she lived in a converted British Rail warehouse in Battersea, London, which also acted as a studio. For want of a bed, she slept in a French Red Cross coffin.

1979

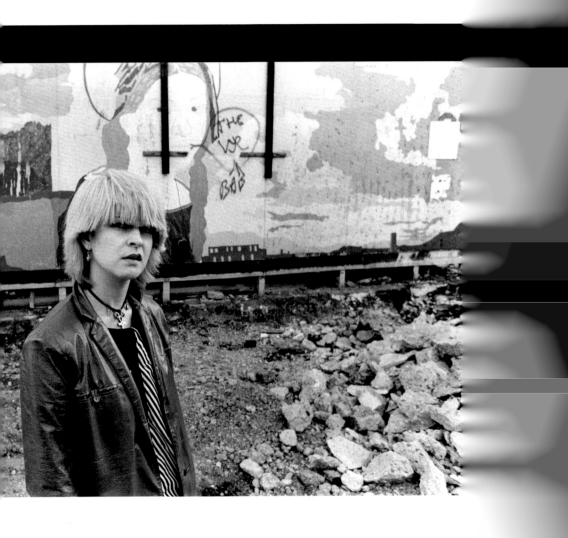

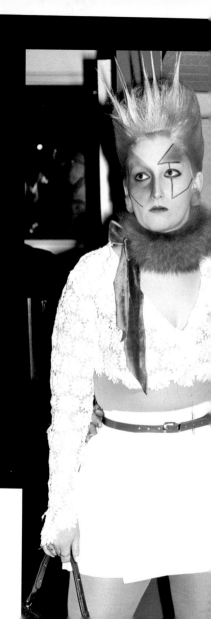

Deep in thought
Left: Punk singer
Wayne County
arrives for the
premiere of Derek
Jarman's film,
Jubilee, in which
she starred.
22nd February, 1978

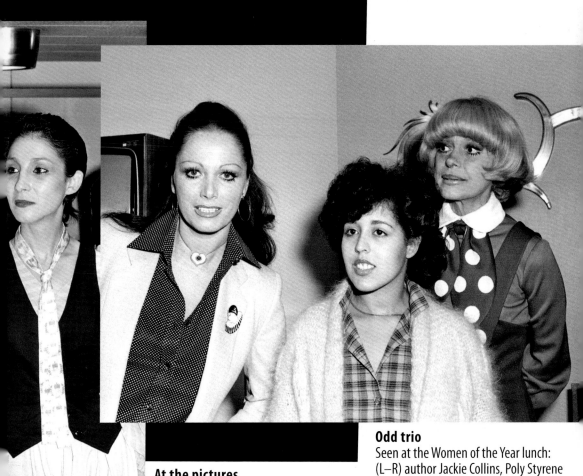

At the pictures
Striking as ever, Jordan arrives with a friend for the premiere of Derek Jarman's punk film, *Jubilee*, in which she starred.
22nd February, 1978

Odd trio
Seen at the Women of the Year lunch: (L–R) author Jackie Collins, Poly Styrene (real name Marianne Elliott-Said), founder of punk band X-Ray Spex, and actress Carol Channing.
29th October, 1979

No sham
Jimmy Pursey, founder and front man of the punk band Sham 69, which would have a major influence on the Oi! movement. Sham 69 had a large skinhead following, and their gigs were often peppered with violence. Indeed, the band stopped performing live after a 1978 gig was broken up by fighting among white-power skinheads.
26th March, 1979

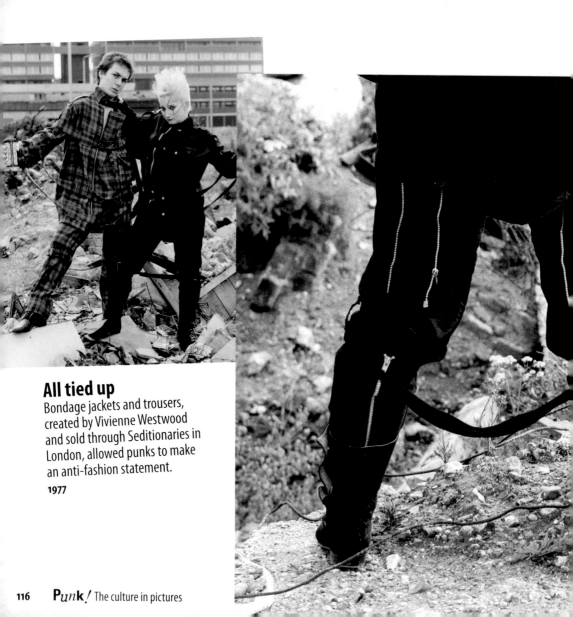

All tied up

Bondage jackets and trousers, created by Vivienne Westwood and sold through Seditionaries in London, allowed punks to make an anti-fashion statement.

1977

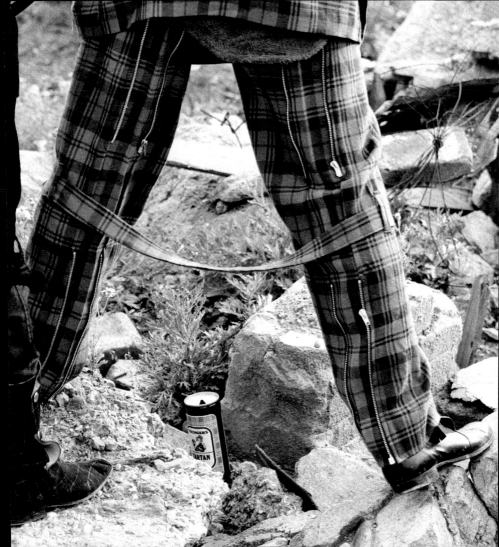

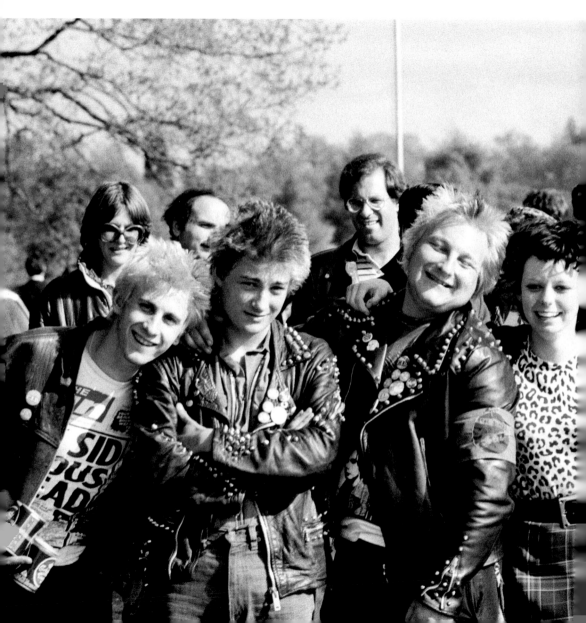

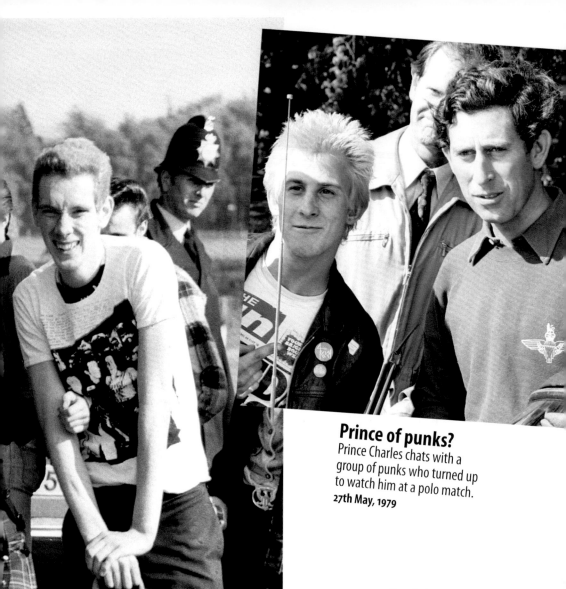

Prince of punks?
Prince Charles chats with a group of punks who turned up to watch him at a polo match.
27th May, 1979

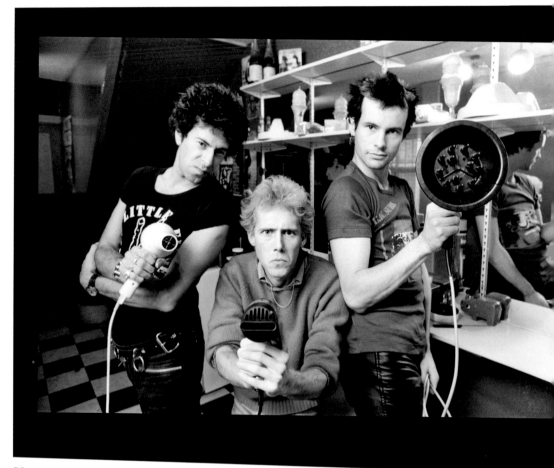

Blown away
UK Subs, one of the earliest British punk bands: (L–R) Charlie Harper (vocals), Pete Davies (drums) and Nicky Garratt (guitar).
14th September, 1979

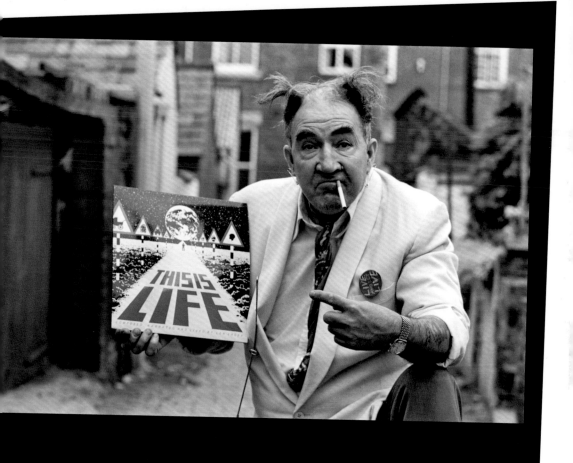

Old-age punk
Len Lacey of Northwich, Cheshire, with his punk album, *This is Life*.
12th September, 1979.

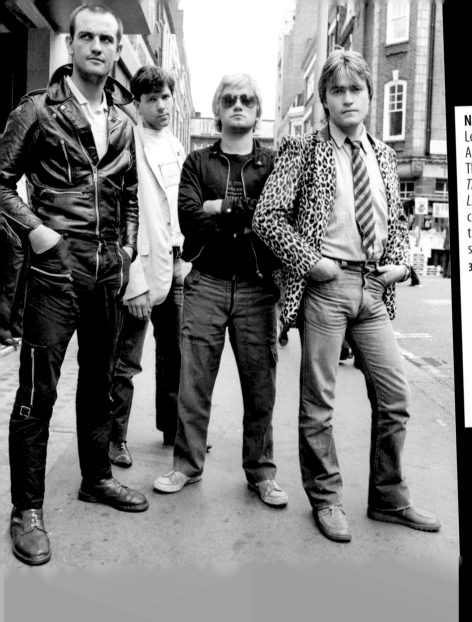

No angels
Left: Punk/Oi! band
Angelic Upstarts.
Their debut single,
*The Murder of
Liddle Towers*, is
considered one of
the best punk rock
singles of all time.
31st August, 1979

Punk pioneers
Right: The
Stranglers, among
the instigators of
the British punk
rock scene.
February, 1979

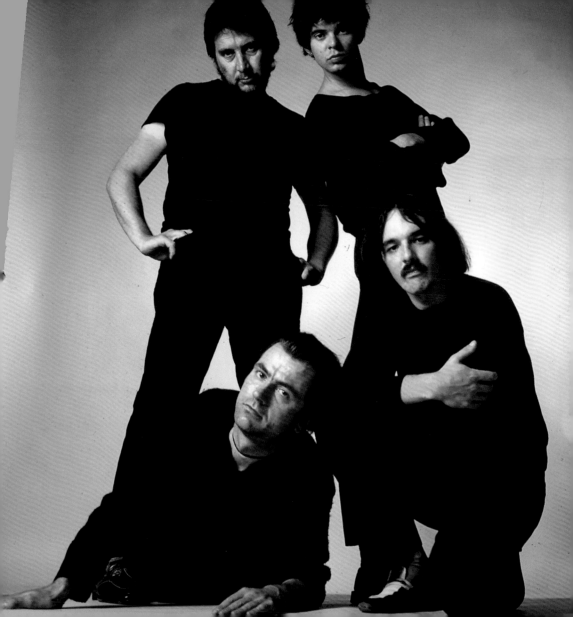

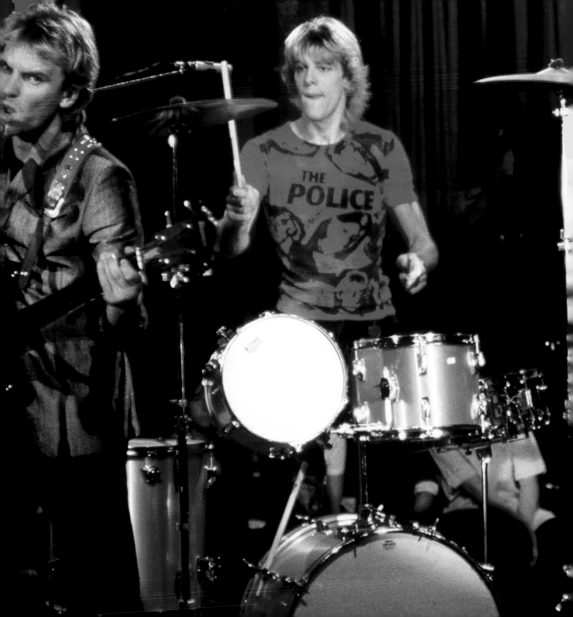

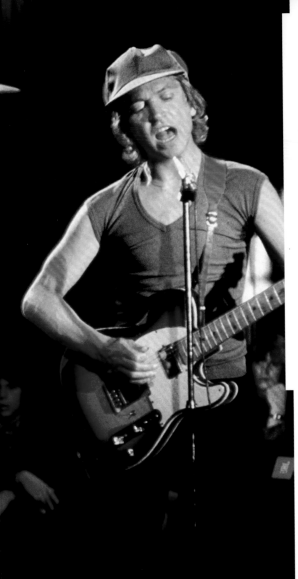

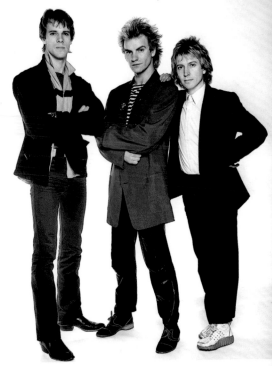

Police men
Above: Stewart Copeland wanted his new band to be part of the burgeoning punk scene, but The Police ended up as one of the first New Wave bands, their music influenced by punk, reggae and jazz. L–R: Copeland, Sting, Andy Summer.
2nd January, 1980

Gigging
Left: The Police play a gig.
1st October, 1981

Go girls

Formed as a punk band on the LA scene in the United States in 1978, the Go-Go's included among their number Belinda Carlisle (top R), who adopted the name Dottie Danger. By 1982, the band had moved away from punk into the New Wave and pop rock genres.

August, 1982

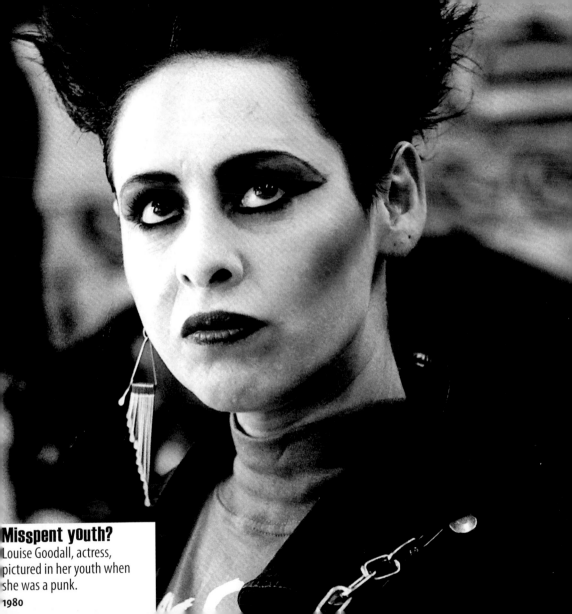

Misspent youth?
Louise Goodall, actress,
pictured in her youth when
she was a punk.
1980

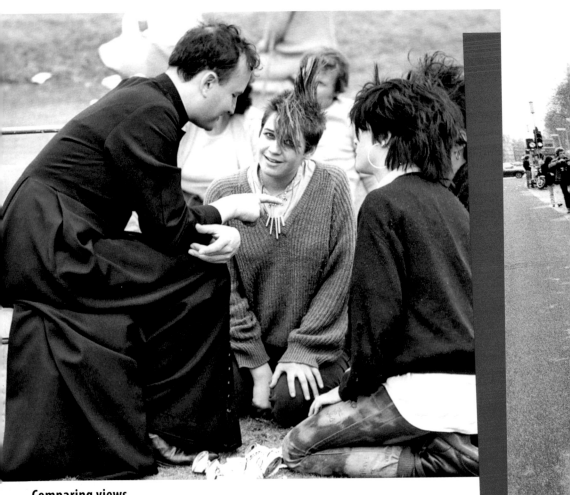

Comparing views
A priest and some punks in debate after listening to
speeches at the Durham Miners Gala.
1980

Punk! The culture in pictures

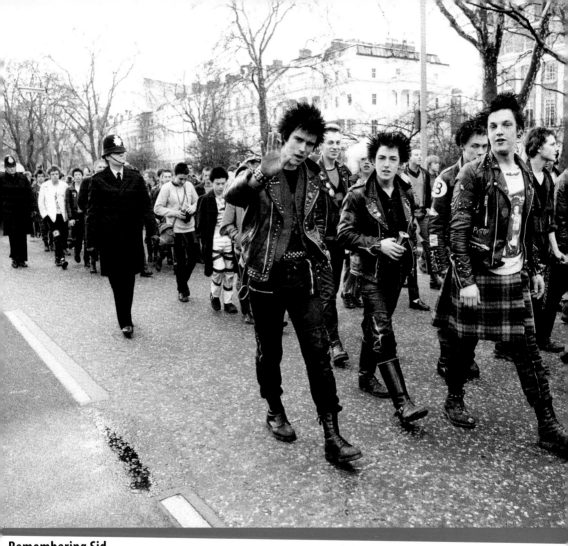

Remembering Sid
Punks march in London to mark the first anniversary of Sid Vicious's death.
3rd February, 1980

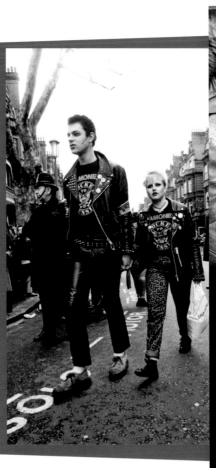

On the march
Punks gather in London to remember
Sid Vicious.
3rd February, 1980

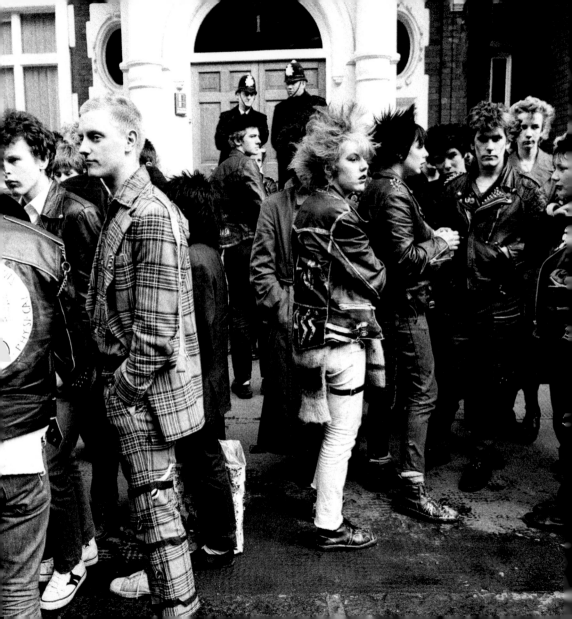

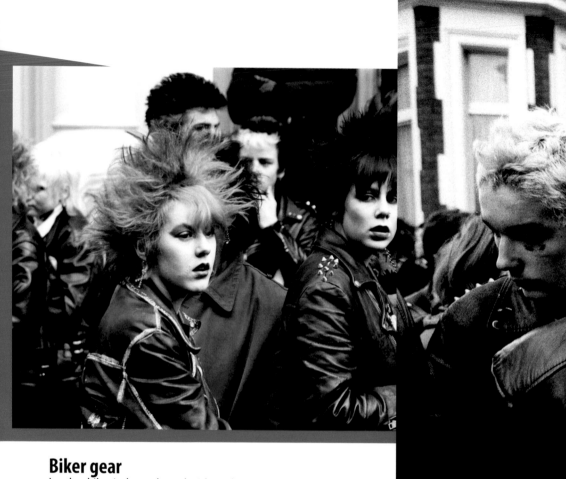

Biker gear

Leather biker jackets adorned with studs,
badges and slogans were synonymous with punk fashion.
3rd February, 1980

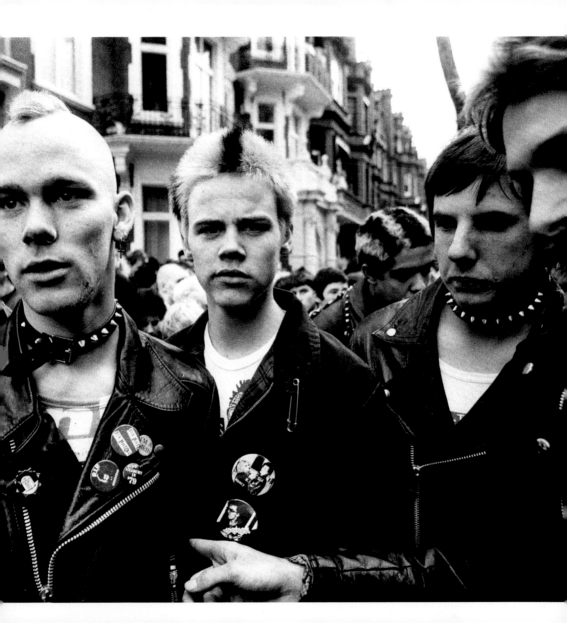

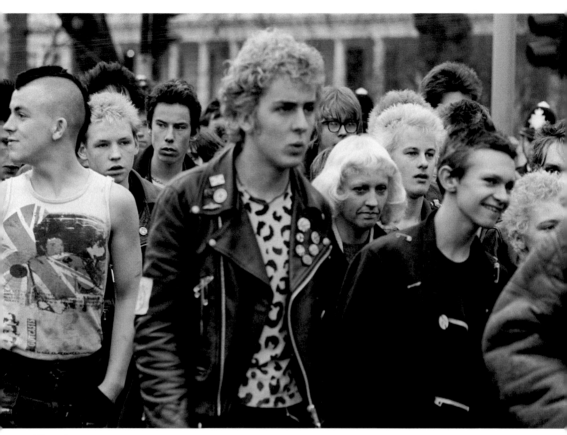

Head cases
Apart from unconventional clothing, eye-catching hairstyles
and colours were important means of punk self-expression.
3rd February, 1980

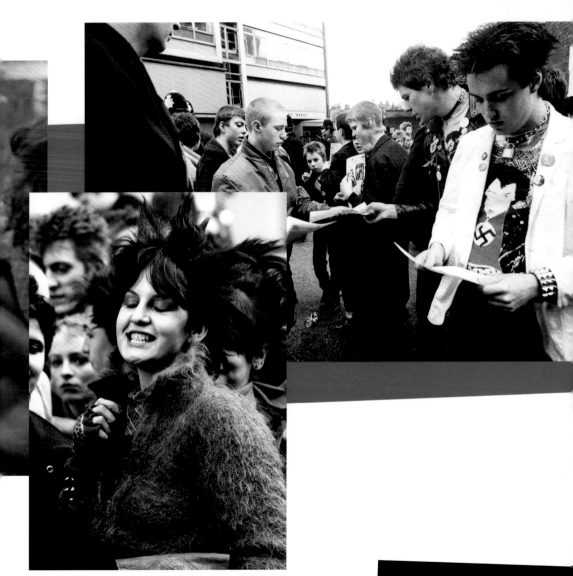

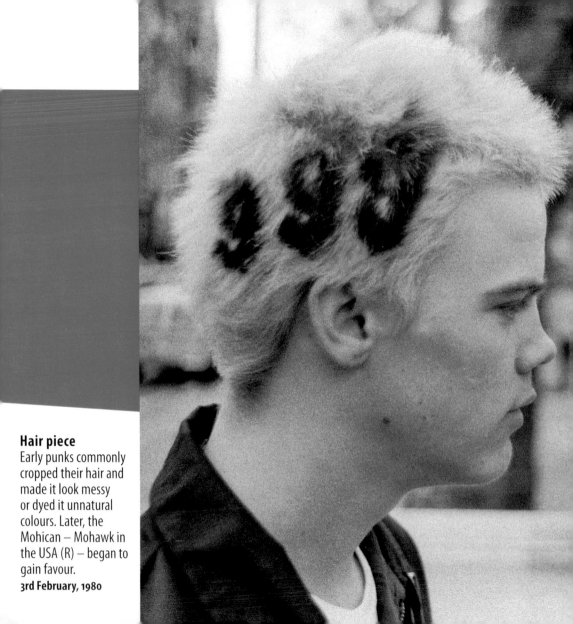

Hair piece
Early punks commonly cropped their hair and made it look messy or dyed it unnatural colours. Later, the Mohican – Mohawk in the USA (R) – began to gain favour.
3rd February, 1980

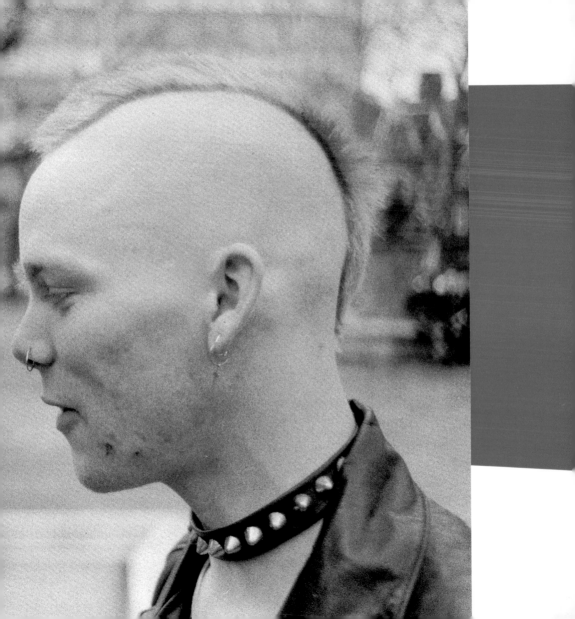

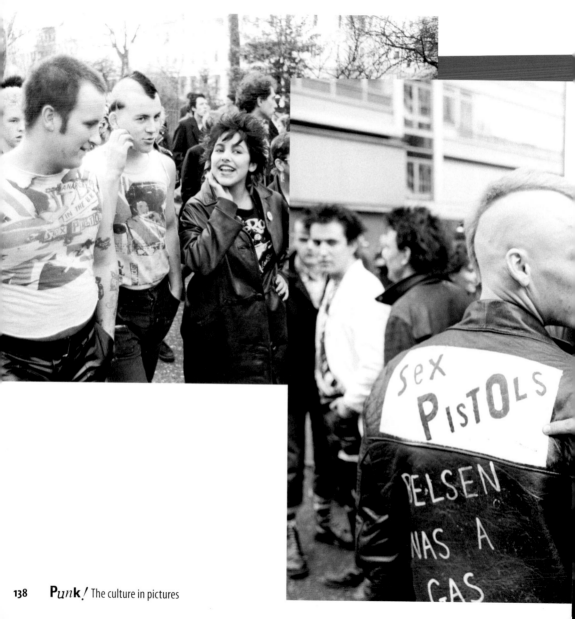

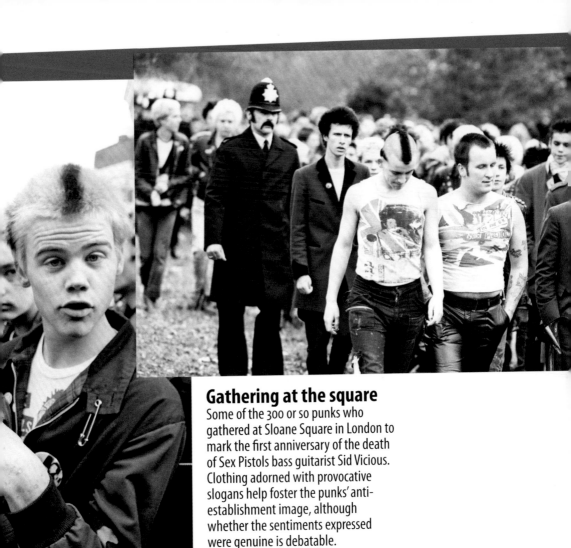

Gathering at the square

Some of the 300 or so punks who gathered at Sloane Square in London to mark the first anniversary of the death of Sex Pistols bass guitarist Sid Vicious. Clothing adorned with provocative slogans help foster the punks' anti-establishment image, although whether the sentiments expressed were genuine is debatable.

3rd February, 1980

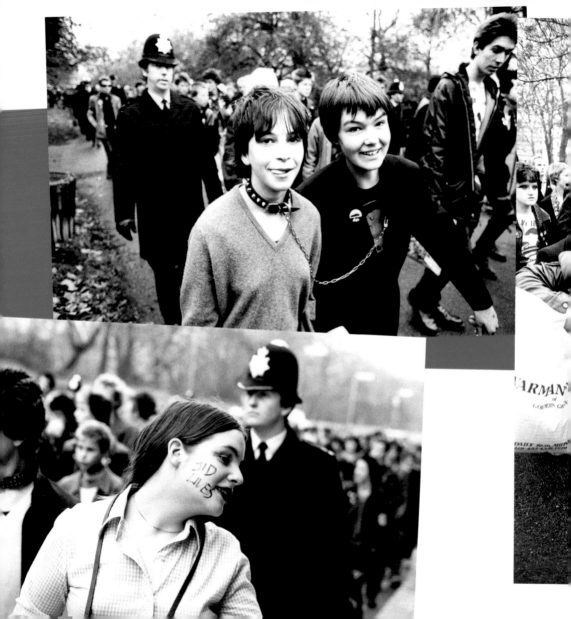

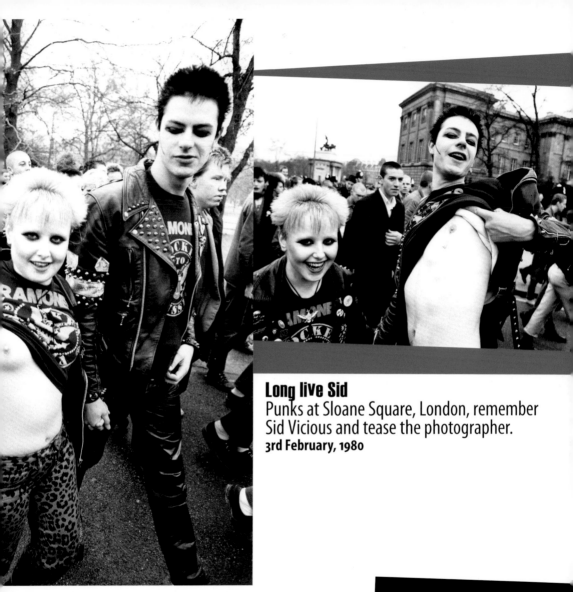

Long live Sid
Punks at Sloane Square, London, remember
Sid Vicious and tease the photographer.
3rd February, 1980

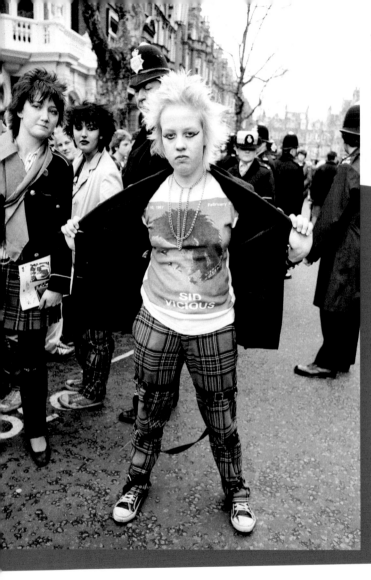

Tartan terror?
Tartan was
another popular
material with
punks, who often
wore short kilts
over bondage
trousers.
3rd February, 1980

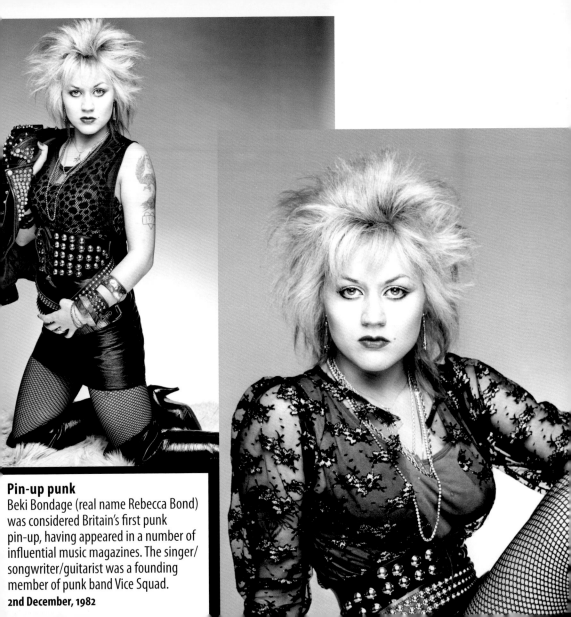

Pin-up punk
Beki Bondage (real name Rebecca Bond) was considered Britain's first punk pin-up, having appeared in a number of influential music magazines. The singer/songwriter/guitarist was a founding member of punk band Vice Squad.
2nd December, 1982

Paper hanger
Hugh Cornwell,
vocalist with
The Stranglers,
contemplates a
little wallpapering.
21st January, 1982

Cat hair
Punk Nigel Smith gets a cheetah hairdo.
25th May, 1980

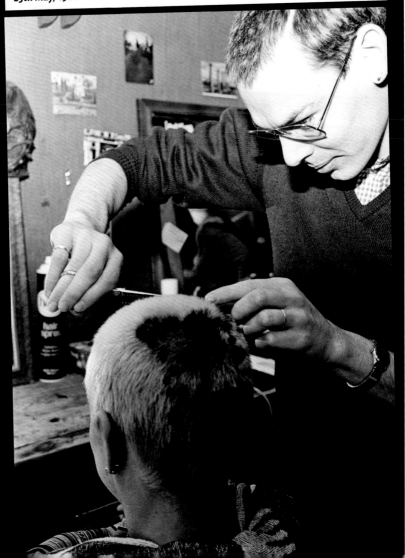

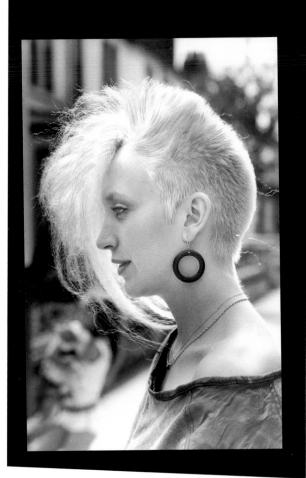

Shocking spikes
Right: Spiked hair for both men and women became increasingly popular and often reached extreme lengths. All intended to shock, which it did.
27th March, 1983

Long and the short
A dramatic combination of cropped and long hair.
1980

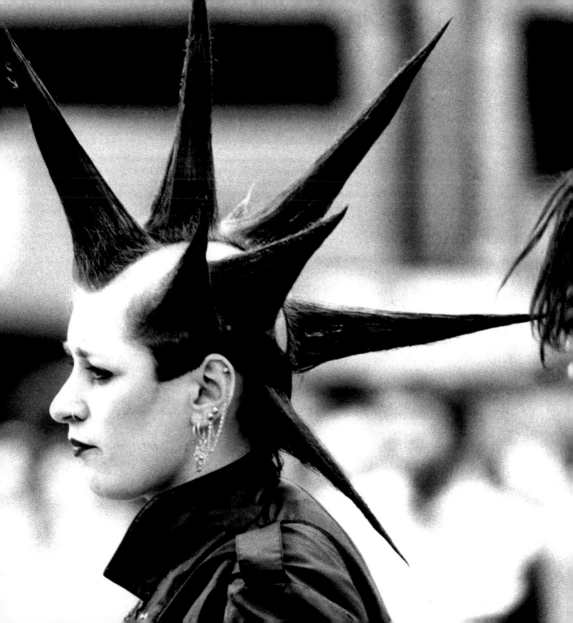

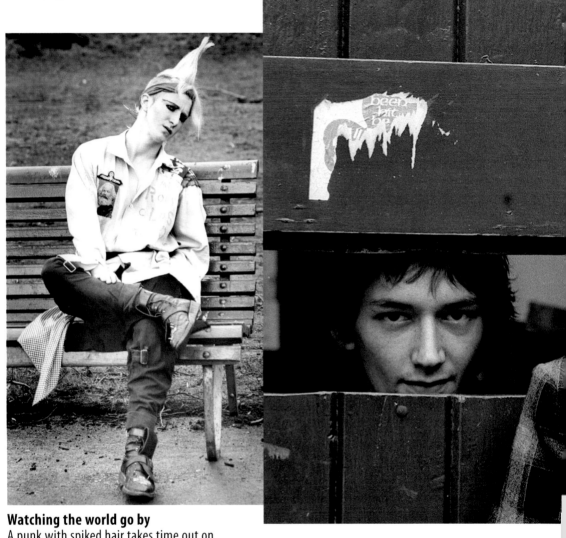

Watching the world go by
A punk with spiked hair takes time out on
a park bench.
September, 1983

New collaboration
Former Sex Pistol John Lydon (R) with songwriter and musician Keith Levene. Lydon had left the Pistols in 1978 and, with Levene, formed Public Image Ltd, arguably the first post-punk band.
18th March, 1981

Fashion shoot
Right: Magazine take on punk fashion: black T-shirt with zips, spray-pattern bondage trousers, black inspector jacket with zips and studded belt.
September, 1983

Going mainstream
Centre right: Toyah Willcox began to move away from her punk roots, but the dramatic hair remained.
5th September, 1983

Going solo
Far right: Billy Idol, originally a member of punk band Generation X, enjoyed further success as a solo artist.
1st August, 1980

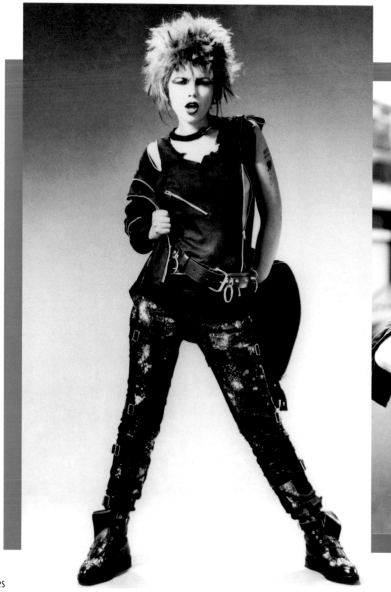

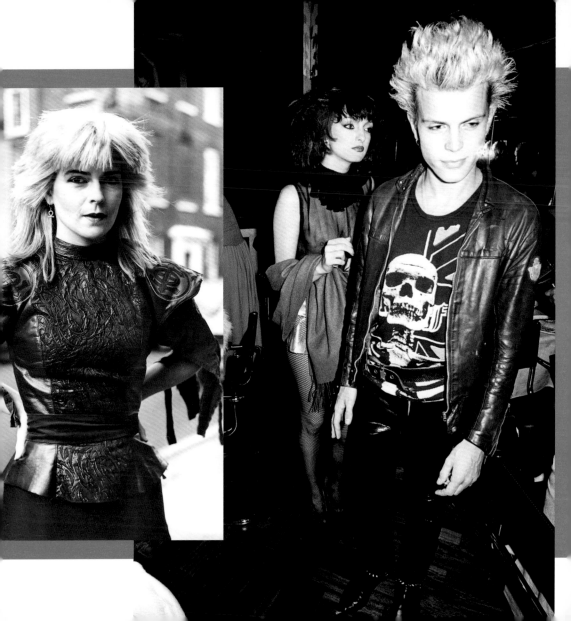

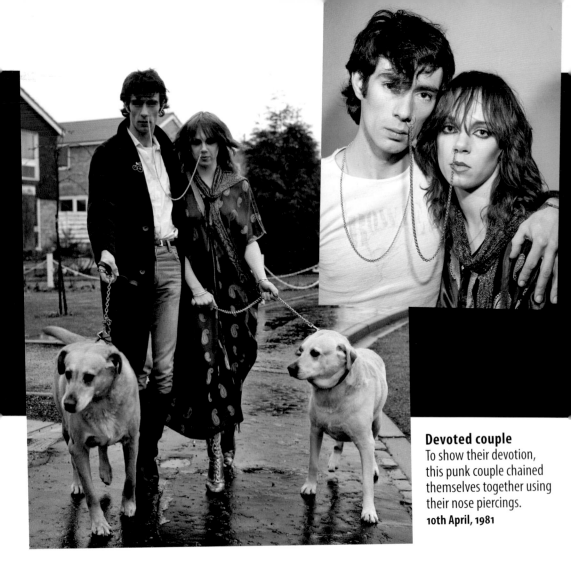

Devoted couple
To show their devotion, this punk couple chained themselves together using their nose piercings.
10th April, 1981

Strange mate
Steve Strange and friend Perry. Strange (real name Steven Harrington) eschewed his punk roots to form the New Wave band Visage, adopting the New Romantic look.
1981

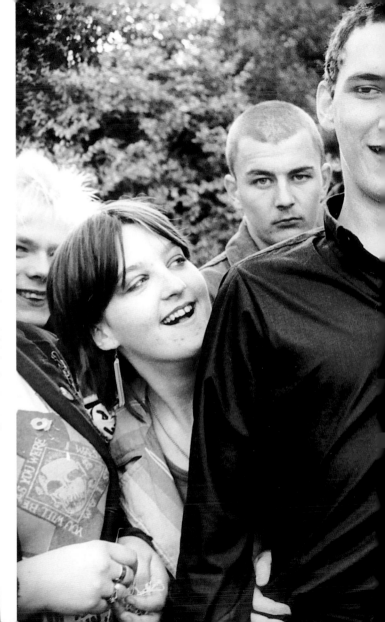

Tying the knot
David Bancroft and
Alison Wyn-de-Bank
celebrate their punk
wedding with friends
and family at Bletchley,
Milton Keynes.
25th October, 1980

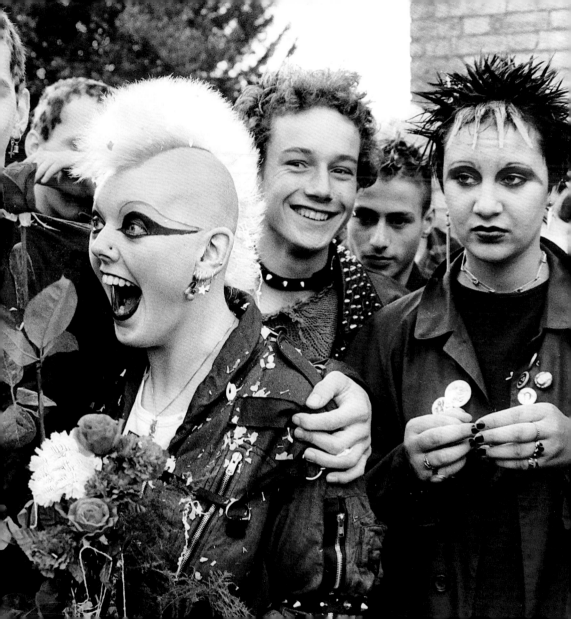

Colourful pair
Right: Startling hair colours, leather jackets, leopard print and tartan: all great ingredients of the punk look.
1981

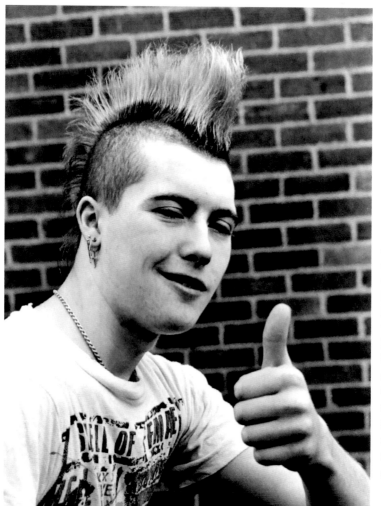

Close shave
Left: Gary Lambadarios won a battle for his job after his flame-coloured Mohican haircut made bosses see red at a television factory in South Wales. Union chiefs went on the warpath when the 18-year-old was ordered to axe the Mohican or join the dole queue.
4th May, 1985

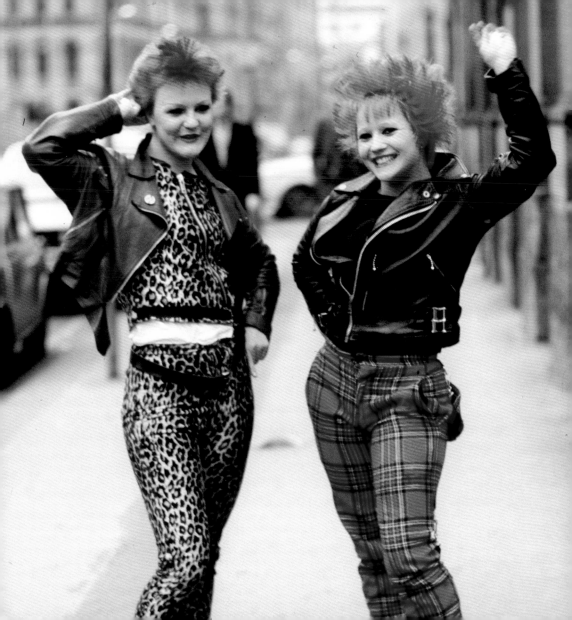

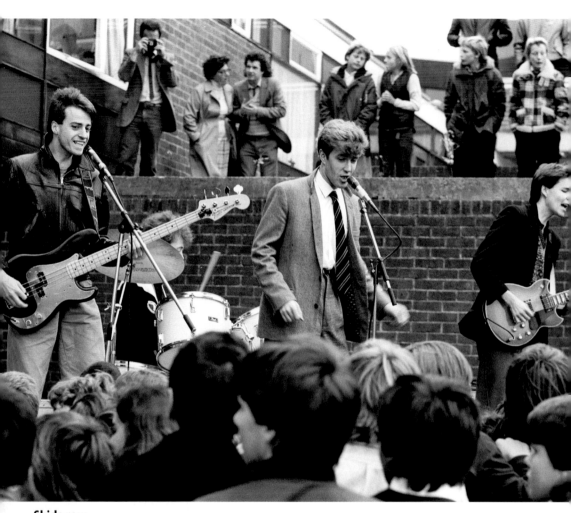

Skids row
The Scottish band Skids perform an outdoor gig in Brighton, Sussex.
16th October, 1980

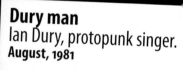

Ant eater
Below: Although recognised now as one of the New Romantics, Adam Ant (real name Stuart Goddard) began his career in the burgeoning punk movement.
1980

Dury man
Ian Dury, protopunk singer.
August, 1981

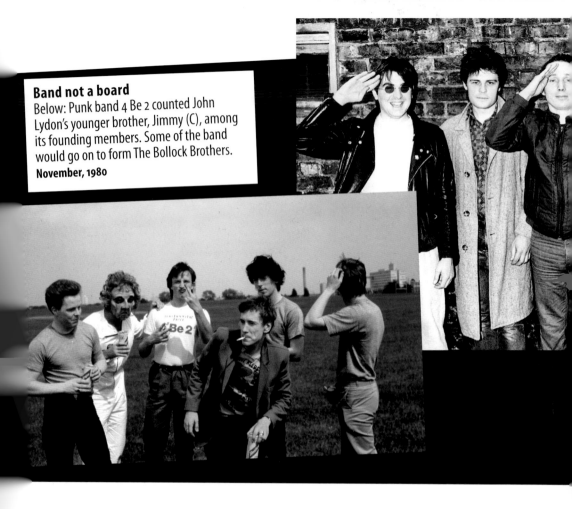

Band not a board

Below: Punk band 4 Be 2 counted John Lydon's younger brother, Jimmy (C), among its founding members. Some of the band would go on to form The Bollock Brothers.

November, 1980

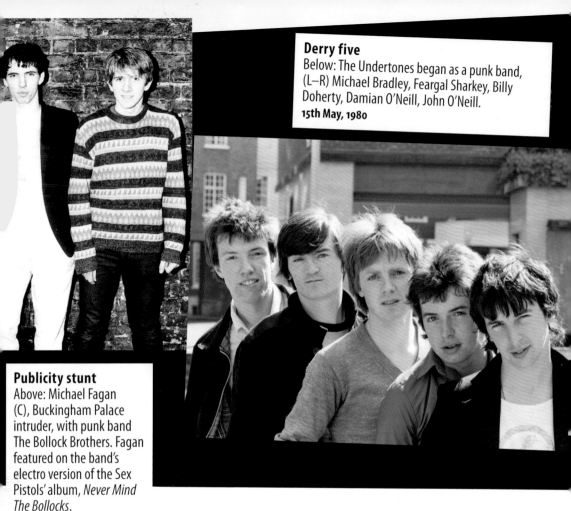

Publicity stunt
Above: Michael Fagan
(C), Buckingham Palace
intruder, with punk band
The Bollock Brothers. Fagan
featured on the band's
electro version of the Sex
Pistols' album, *Never Mind
The Bollocks*.
27th April, 1983

Broken up
Above: Coventry band The Wild Boys, who finally broke up in 1981.
16th October, 1981

Pilchards and bums
Right: Splodgenessabounds play a gig in Nottingham.
Characterised as 'punk pathetiques', the band injected humour
into its act, singing about pilchards and bums, unlike other Oi!
bands, who addressed serious working-class issues, like the dole.
21st March, 1981

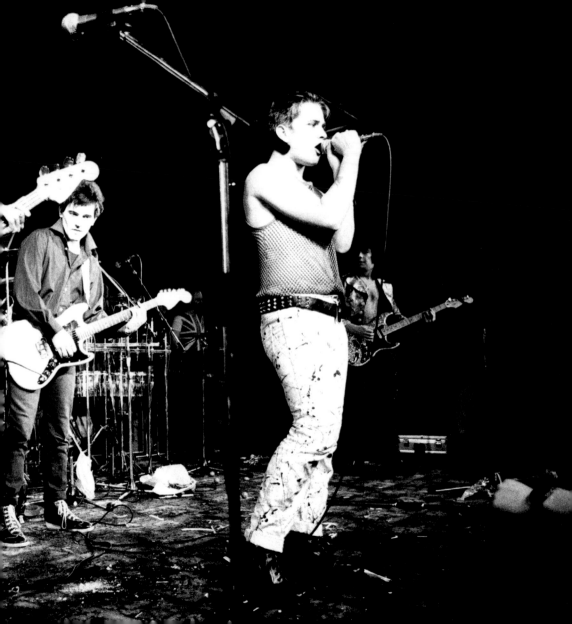

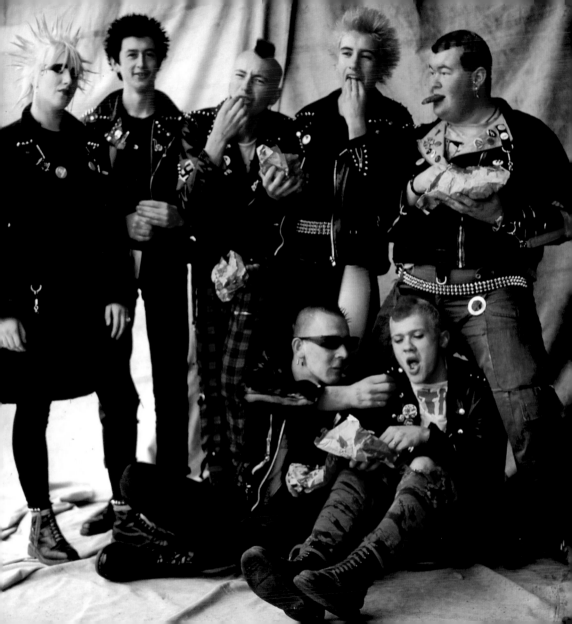

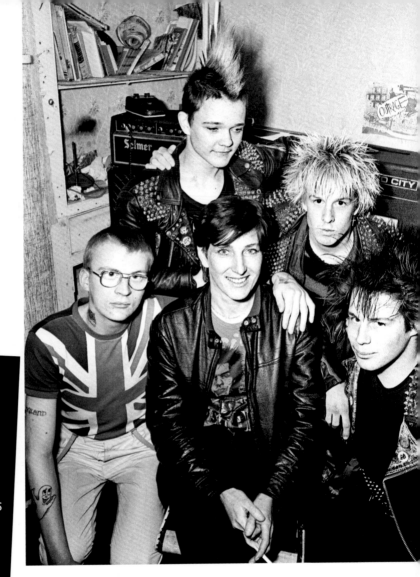

Tucking in
Left: Scottish punk band
The Exploited enjoy
a light snack.
November, 1980

Ready to rock
Right: Punk band with their
amps crammed into someone's
front room.
1980

Punks in the park

Kilts, both full-length and short, became a favourite form of dress among punks, who wore them over tartan or other trousers. A bum flap was a popular addition to a pair of bondage trousers.

30th March, 1980

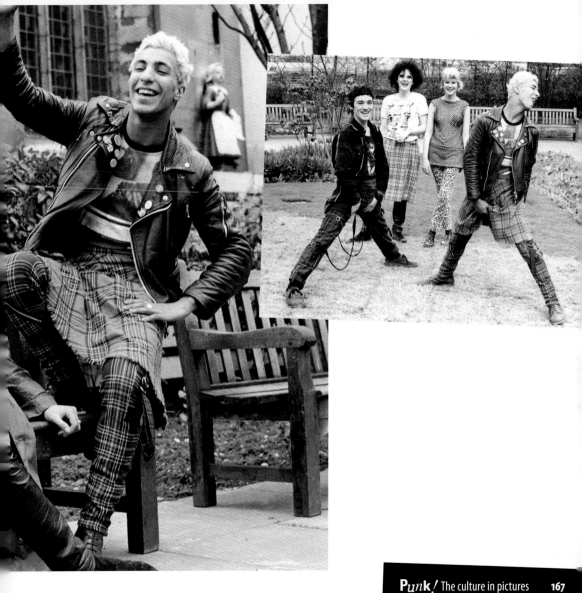

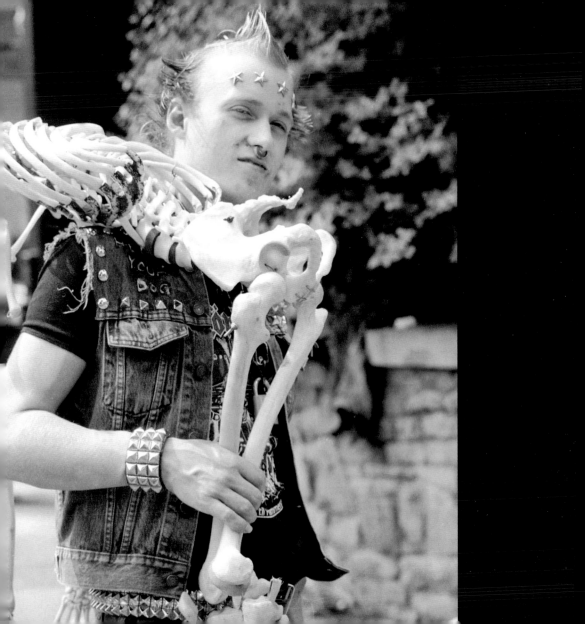

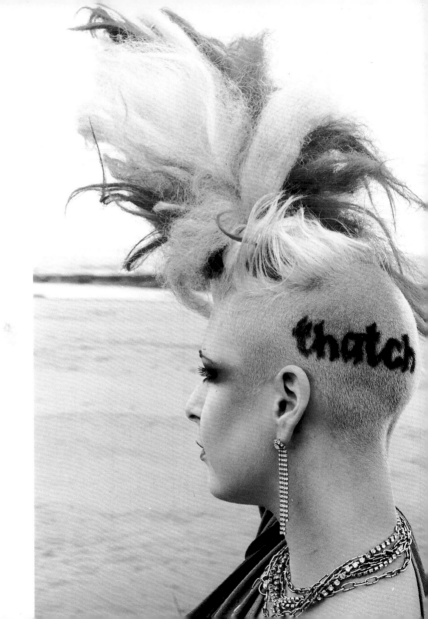

Punk portrayal

Left: Adrian Edmondson, who played violent punk student Vyvyan in the TV sitcom *The Young Ones.* Edmondson's portrayal included a studded forehead – a step too far perhaps for even the most ardent of punks.
April, 1982

Trick of the trade

Right: Hairdresser Sharon McArthur displays her exotic punk hairstyle.
13th October, 1984

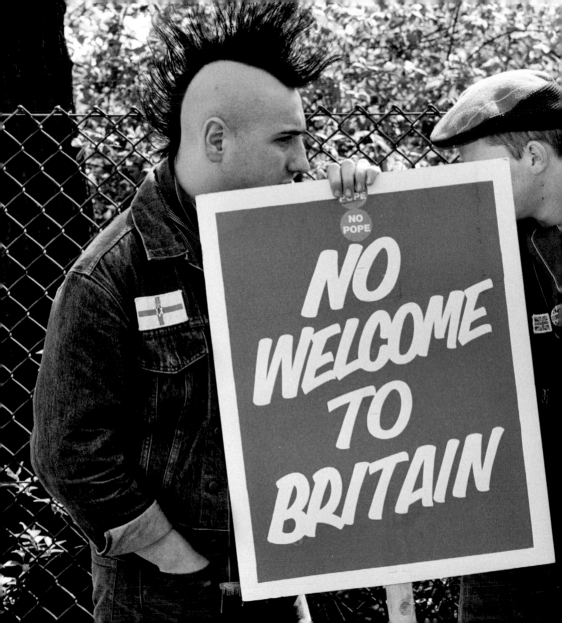

POPE
NO POPE

NO
WELCOME
TO
BRITAIN

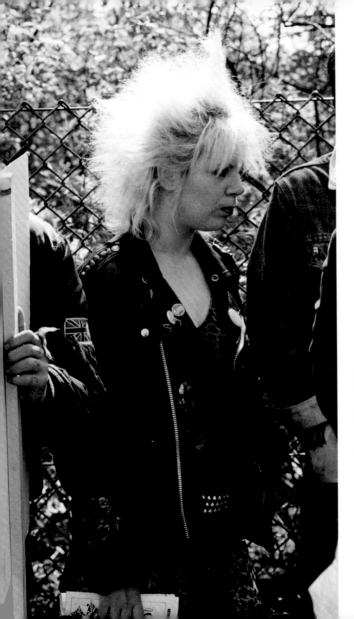

Punk protest
Punks gather for a march
to protest at the Pope's
forthcoming visit to Britain.
17th April, 1982

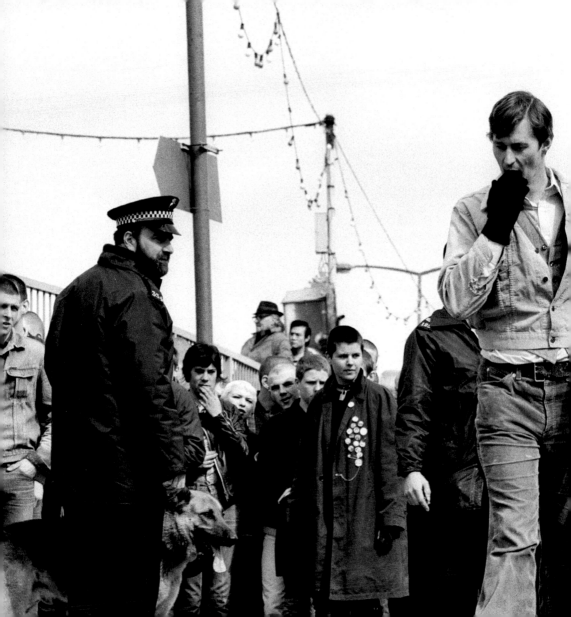

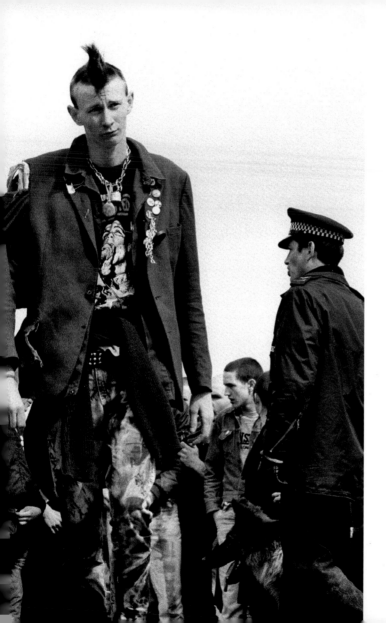

Rumble at Sarfend
Punks and skinheads
cause trouble at
Southend, Essex.
12th April, 1982

Hair today...
Tesco worker Dave
Liddle considers his
options after being
told he had a choice
between his haircut
and his job.
28th April, 1983

They mattered

The Clash: (L–R) Paul Simonon, Nicky Headon, Joe Strummer, Mick Jones.
In their heyday, they were known as 'the only band that matters'.
21st April, 1982

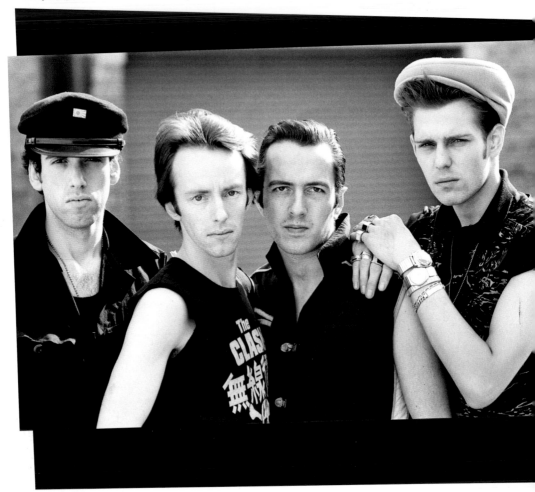

Party punks
The Ace fashion shop in the King's Road, Chelsea holds a party for its showbiz clients, among them (L–R) Steve Strange, Billy Idol and Paul Tok.
25th September, 1982

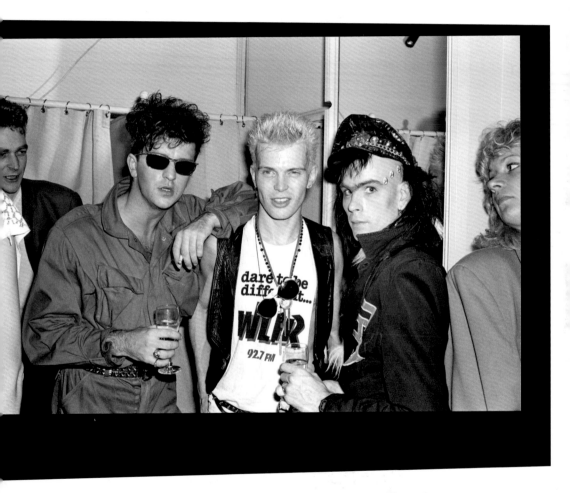

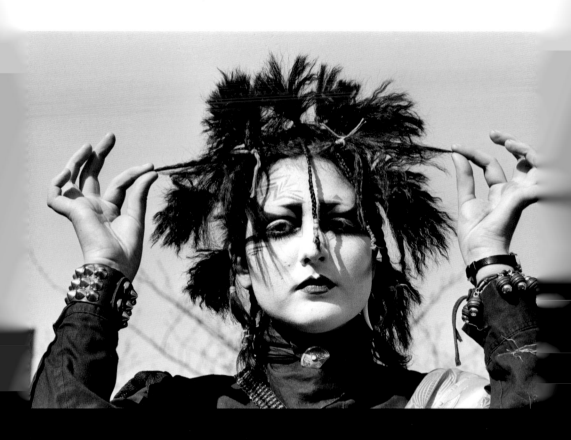

Topknots
Maria Perez shows off her crowning glory and striking eye make-up.
10th April, 1981

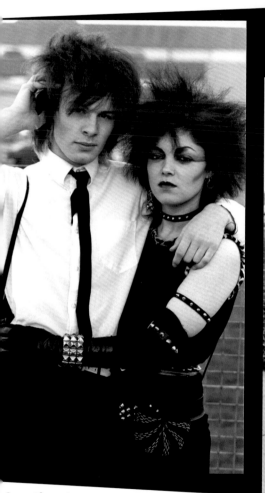

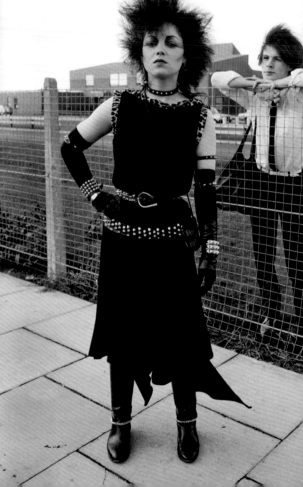

Sweethearts
Punks Brian McEnaney (15) and girlfriend Lesley
Smith (24) are separated by the school fence.
30th December, 1981

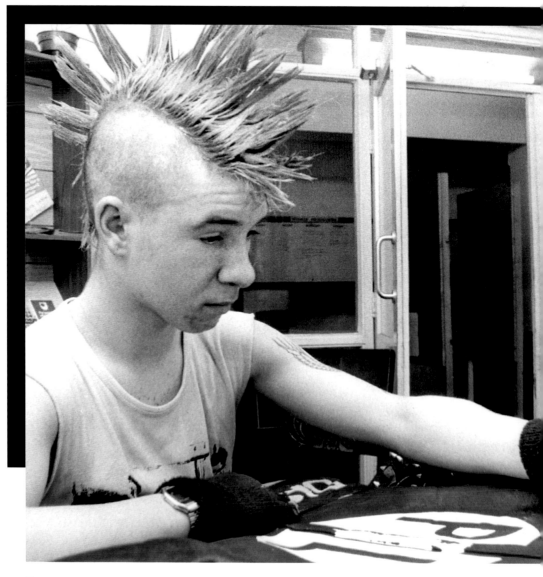

Pu**nk**! The culture in pictures

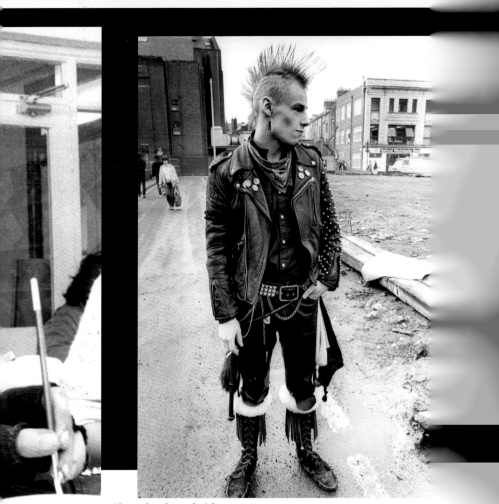

Short back and sides
Left: Sean Hewitson from Newbiggin, Northumberland, proudly
wears his Mohican hairstyle.
March, 1984

Punk!

Spikes and studs
Right: James O'Donald, from Glasgow, seen in the King's Road, Chelsea. His hair is in the classic spiked Mohican style.
March, 1983

Hair raiser
Far right: Janet Lazard's amazing hair.
January, 1985

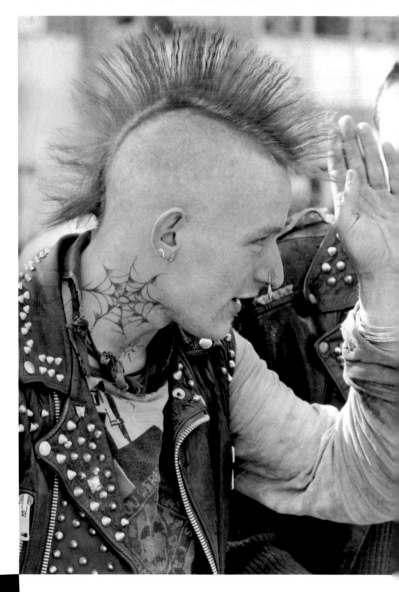

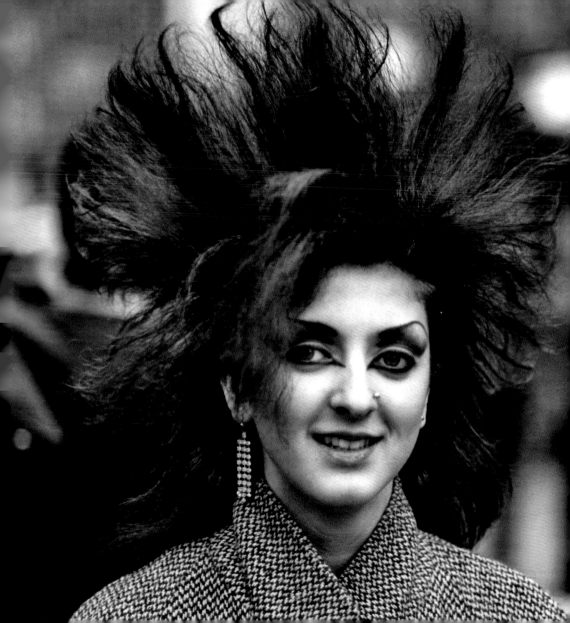

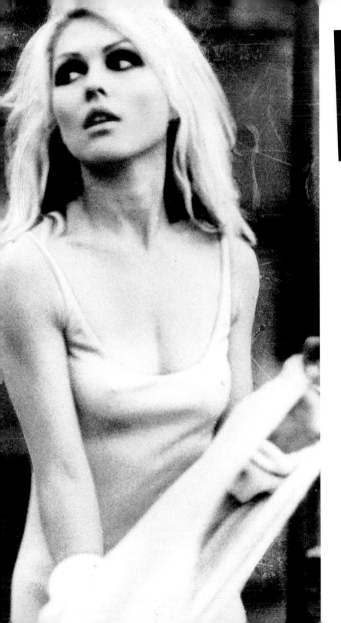

Platinum blonde
Left: Debbie Harry, singer with the American punk/New Wave band Blondie.
18th March, 1984

Book launch
Right: Debbie Harry and Chris Stein, co-founders of Blondie, at a party to celebrate publication of *Making Tracks – The Rise of Blondie*.
20th May, 1982

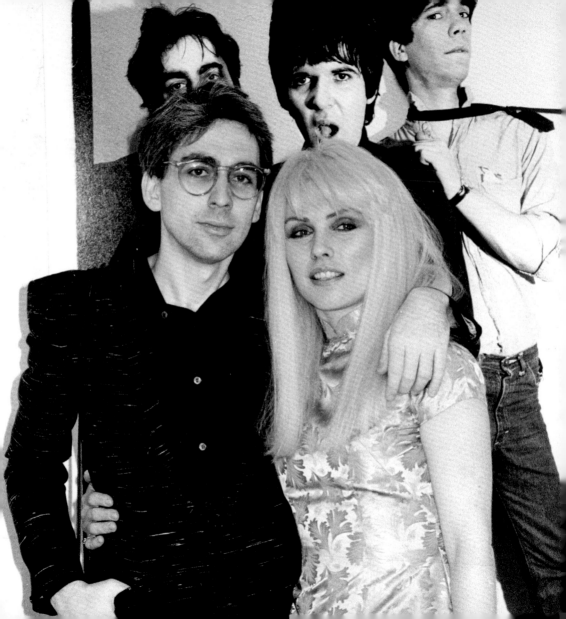

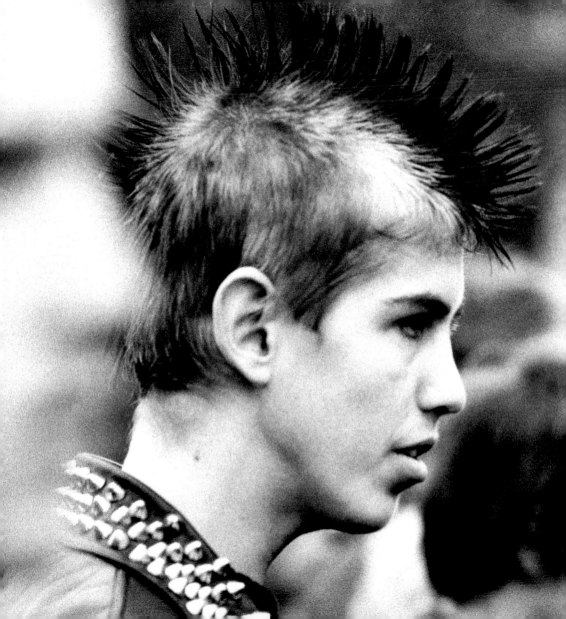

Stand-ups

Even relatively short hair could be turned into a Mohican or a series of random spikes with the aid of soap or gel.

1980

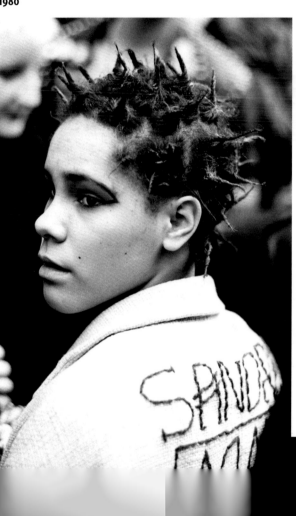

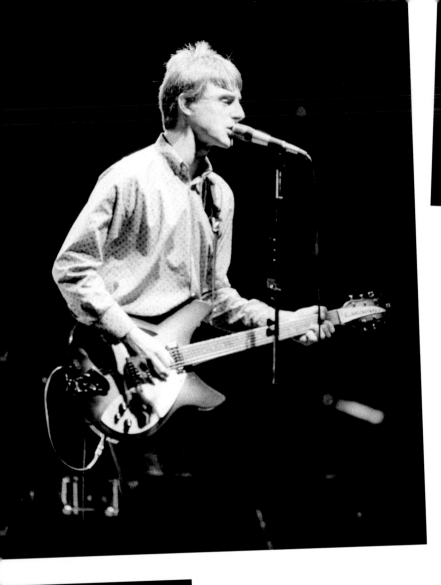

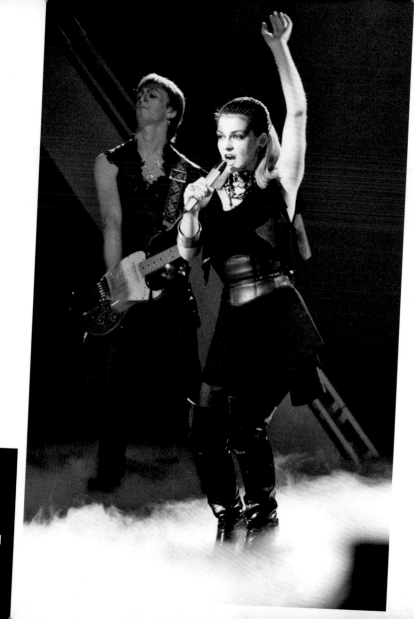

Mystery girl
Toyah Willcox performing at the Rock and Pop Awards.
24th February, 1982

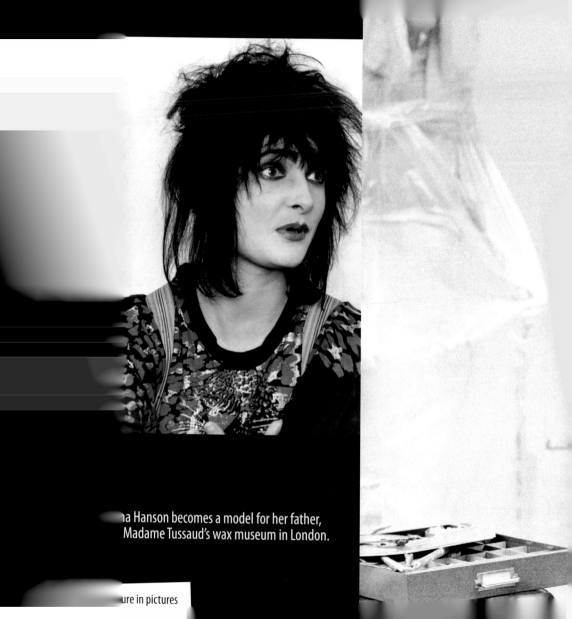

a Hanson becomes a model for her father,
Madame Tussaud's wax museum in London.

ure in pictures

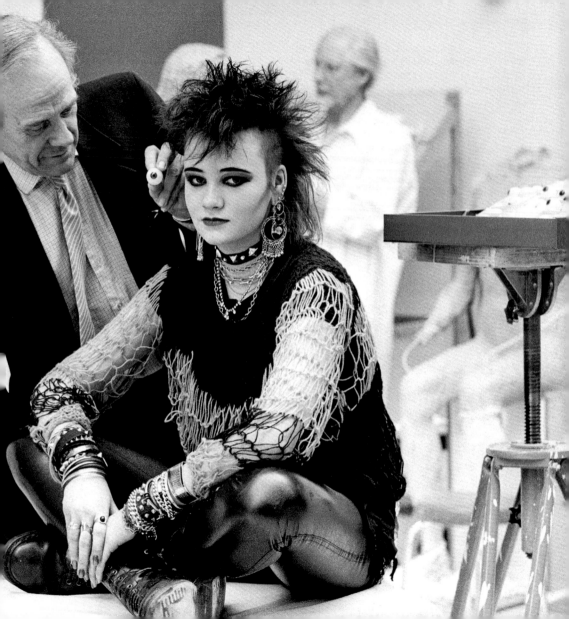

Nice boys
Adam and The
Ants in their 'dandy
highwaymen' days,
having left the punk
scene behind. This
photo was taken
at The Palladium
in Hollywood, USA,
where Adam would
be voted the 'sexiest
man in America' by
viewers of MTV.
December, 1982

On the Beeb
Toyah Willcox moved steadily away from the punk scene, although she retained her flame-coloured hair (R). She developed her acting career, appearing in the BBC comedy *Dear Heart* (L).
1982

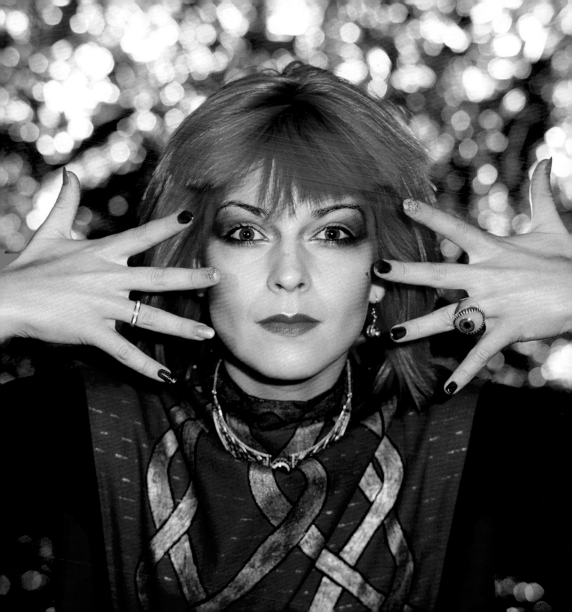

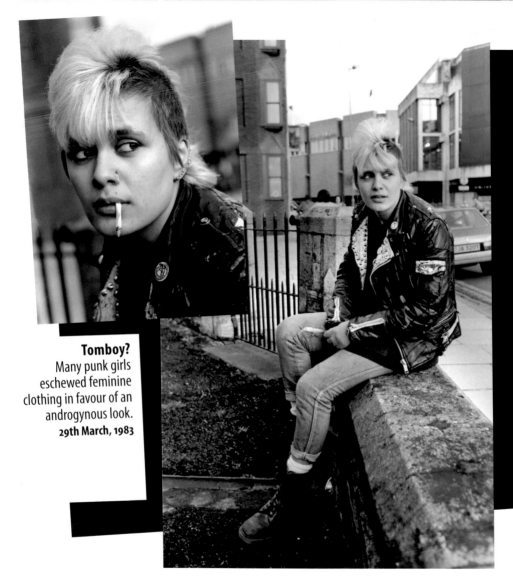

Tomboy?
Many punk girls
eschewed feminine
clothing in favour of an
androgynous look.
29th March, 1983

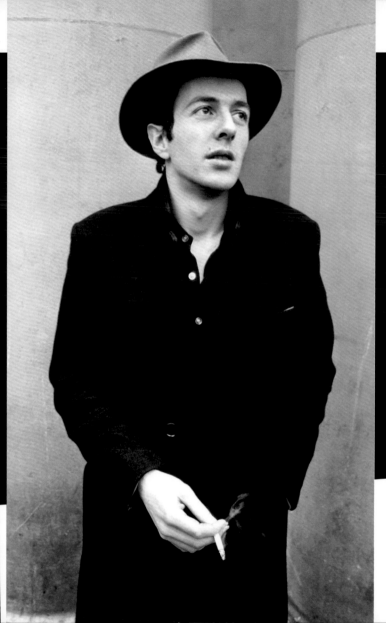

Punk icon
Joe Strummer (real name John Mellor) of The Clash, considered to be one of the most iconic figures of the punk movement.
16th January, 1981

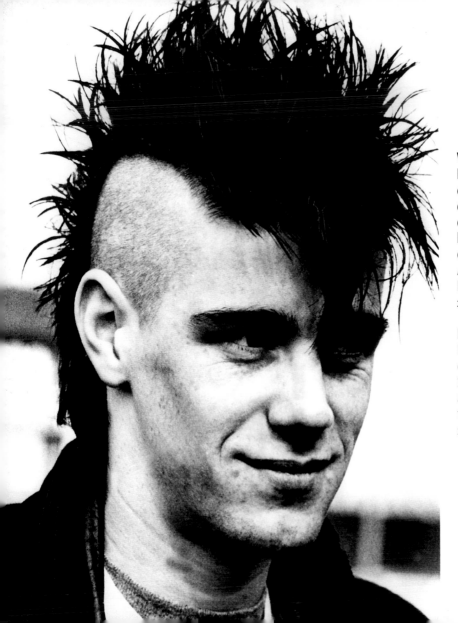

Variation on a style
Left: Mohican hairstyles could be very narrow or much broader with only the sides of the head shaved, like that of geography student Andrew Askins from Penrith, Cumbria.
27th April, 1983

Nice hair
Right: The Prince of Wale chats to punks Beverley Scott (L) and Mary Murra at Consett during a tour the Northeast.
22nd October, 1984

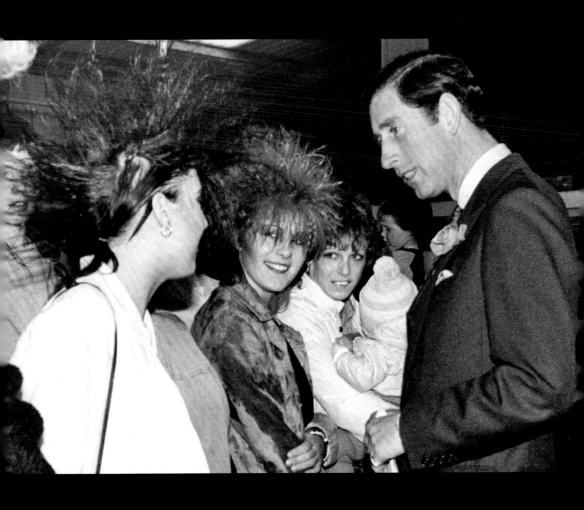

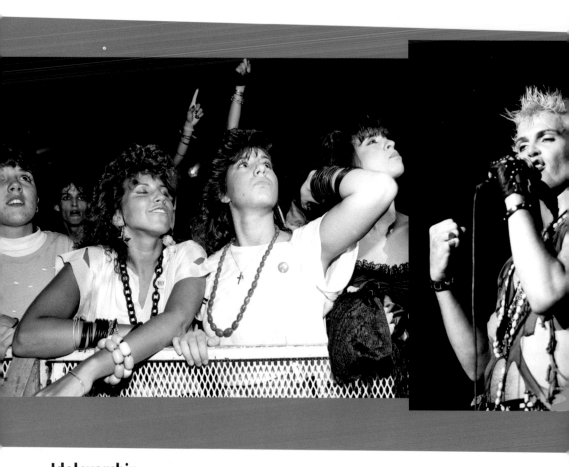

Idol worship
Billy Idol in concert on Long Island, New York, USA.
11th September, 1984

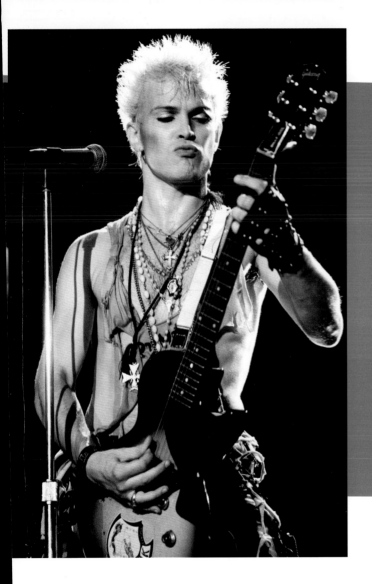
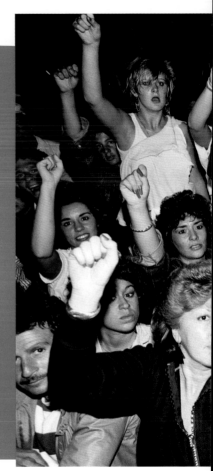

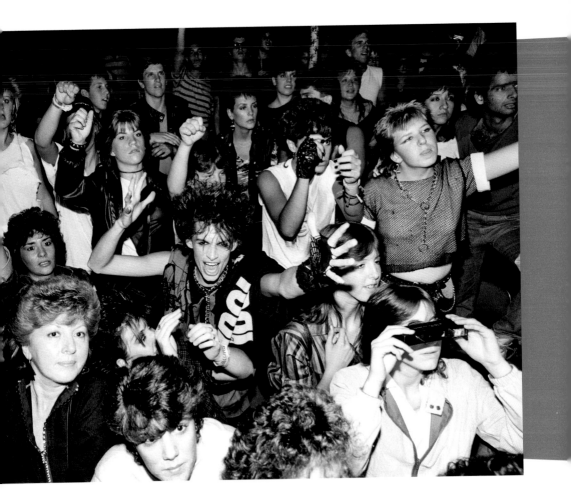

Solo success
Billy Idol moved to New York after Generation X disbanded in 1981. There he pursued a successful solo career.
11th September, 1984

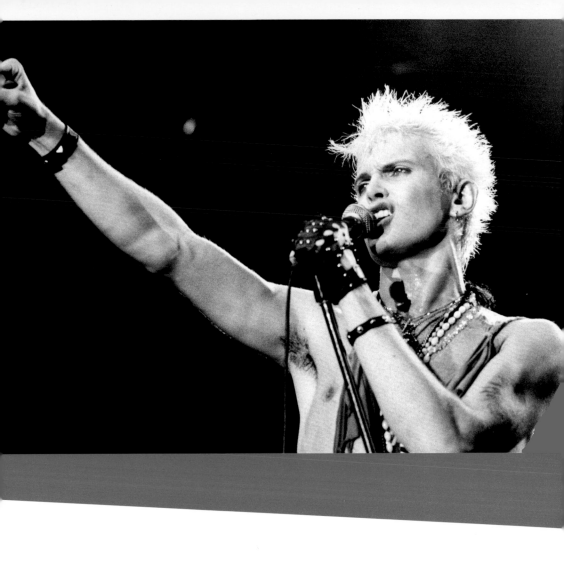

Sioux Who?

Right: Guitarist Pete
Townsend of The Who and
Siouxsie Sioux attend the
launch of an anti-drug
campaign.

19th April, 1985

Prince's pair

Far right: Punk couple
Sharlene Burnell and
Gary Telford, who were
photographed by Prince
Andrew for a calendar.

5th April, 1984

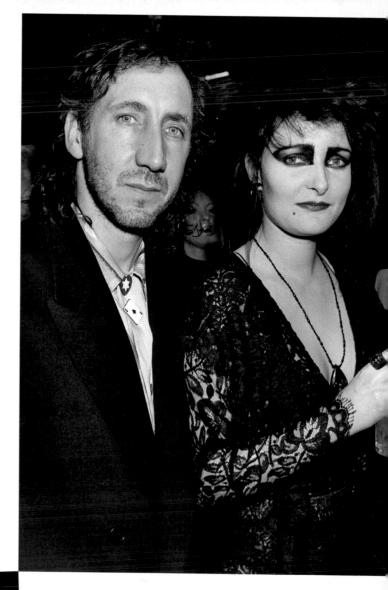

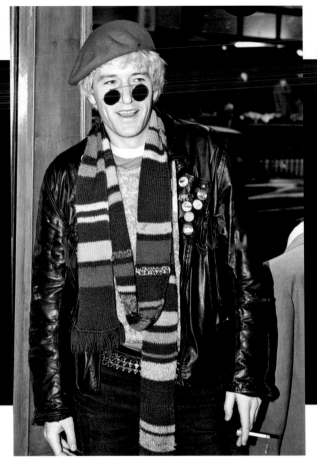
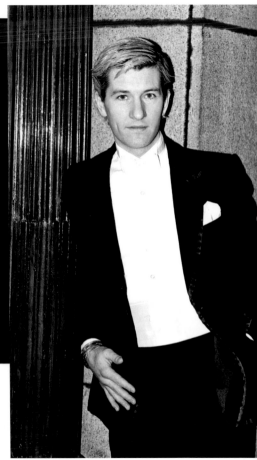

Scrubs up nice
The two sides of Captain Sensible, co-founder of The Damned.
1983

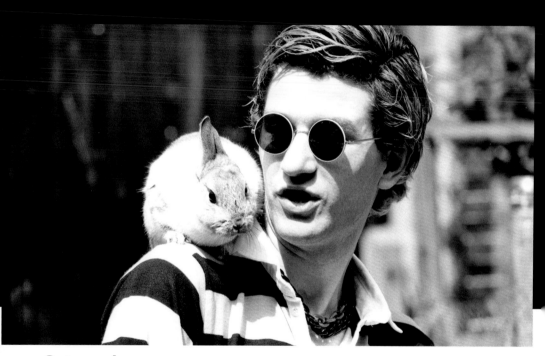

Pet sounds
Captain Sensible at home with Rabbit, his pet rabbit.
13th June, 1984

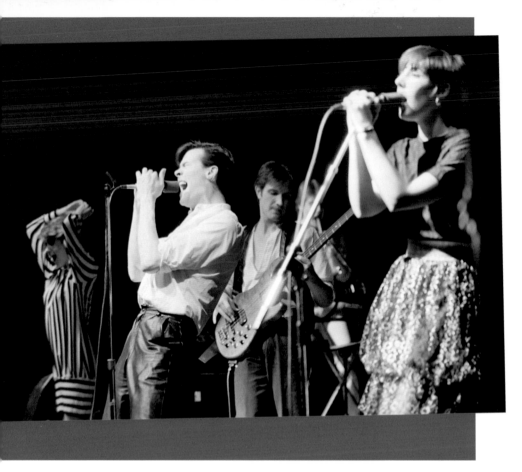

Only human
New Wave band Human League, fronted by
vocalist Philip Oakey (second L). They favoured
the New Romantic style, but their work still
had elements of punk rock.
17th May, 1982

Making a statement
Right: Messed up, coloured
hair made an anti-
establishment statement.
1985

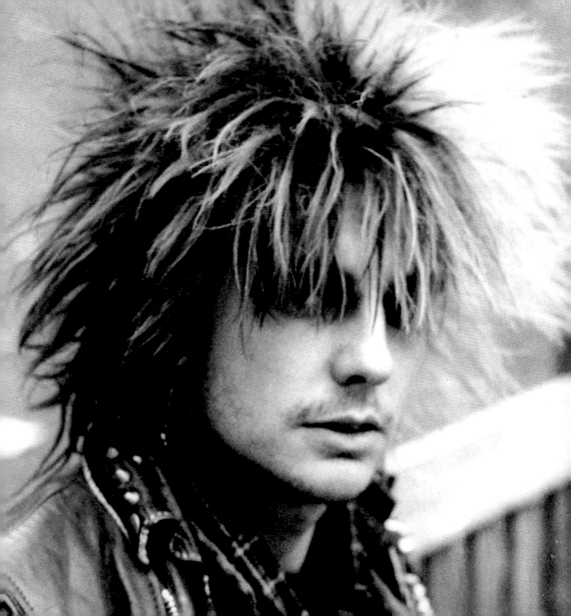

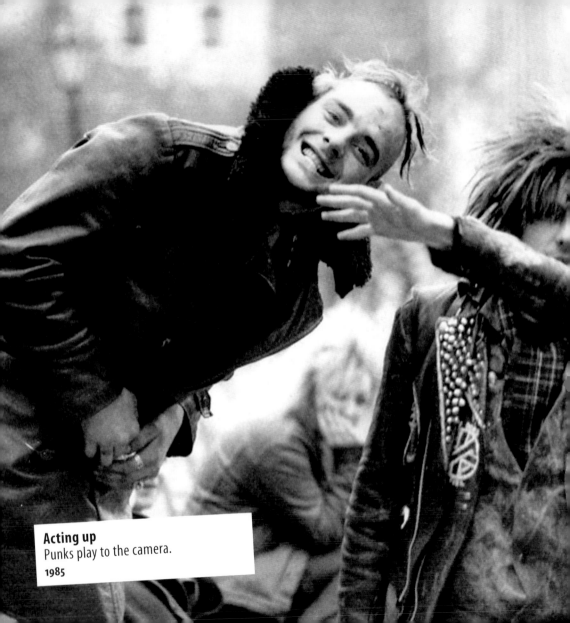

Acting up
Punks play to the camera.
1985

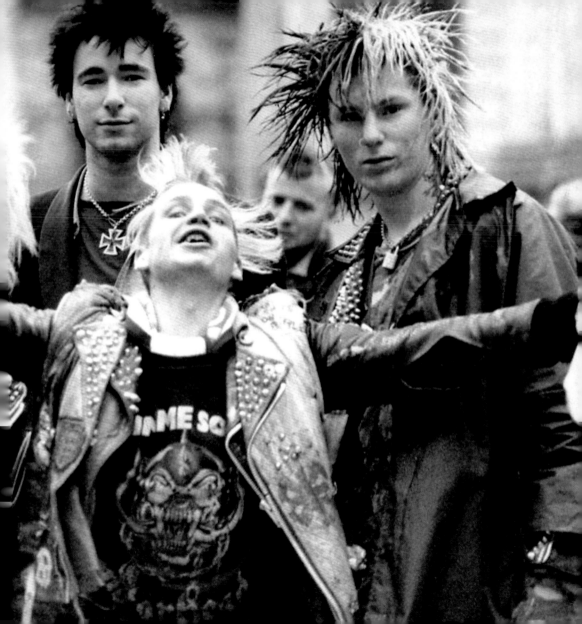

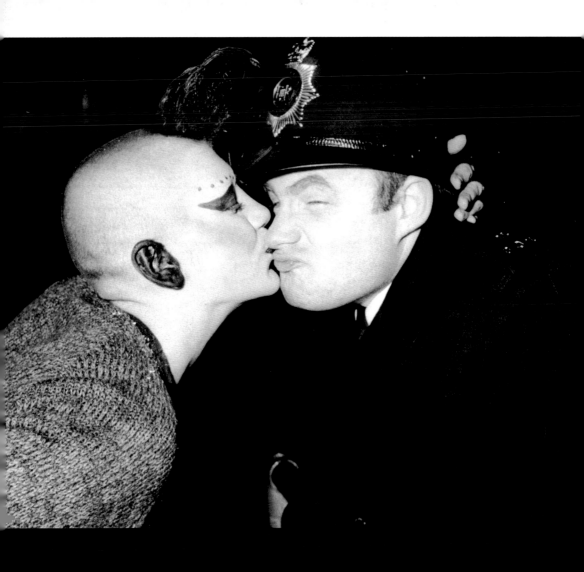

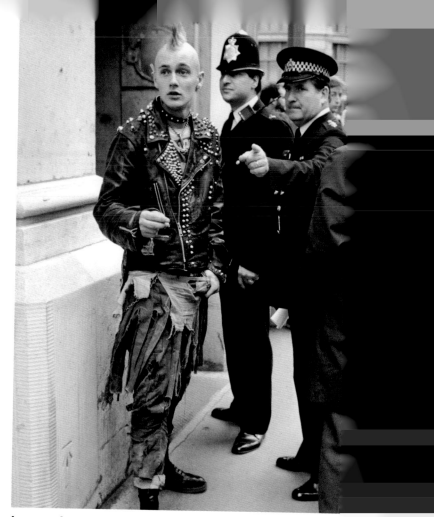

Pucker punk
Left: A policeman receives a kiss from a girl punk in Trafalgar Square, London on New Year's Eve.
1st January, 1984

Lost punk
Policemen outside the Bank of England direct a punk demonstrator to the Stop the City protest.
27th September, 1984

Pu**nk***!* The culture ir

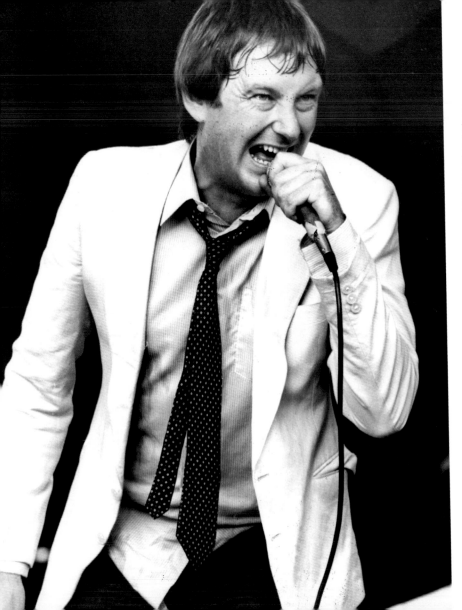

Paving the way

Left: Lee Brilleaux of pub rock band Dr Feelgood. The band's hard, R&B-influenced rock'n'roll paved the way for punk bands like The Stranglers.

30th August, 1981

Velvet Lou

Right: American singer/songwriter Lou Reed, formerly a member of The Velvet Underground, also had an influence on early punk musicians.

31st March, 1987

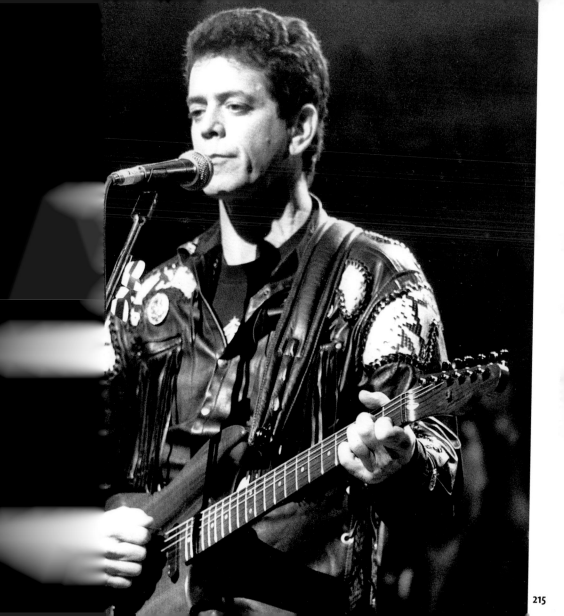

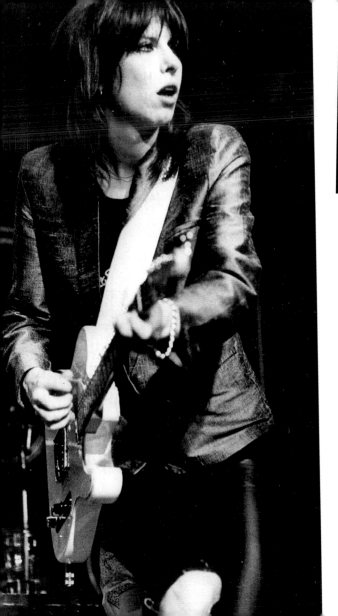

Not pretending
Left: Chrissie Hynde on stage. Hynde had been involved with several unsuccessful punk bands before forming The Pretenders in 1978.
1982

Cramps Interior
Lux Interior (real name Erick Purkhiser), singer with American band The Cramps.
20th April, 1986

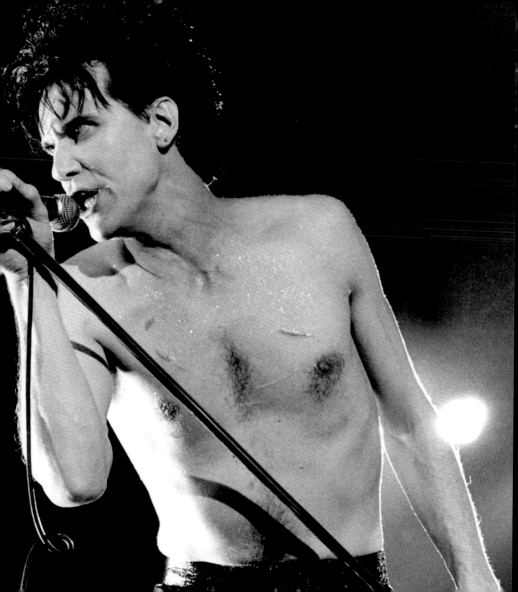

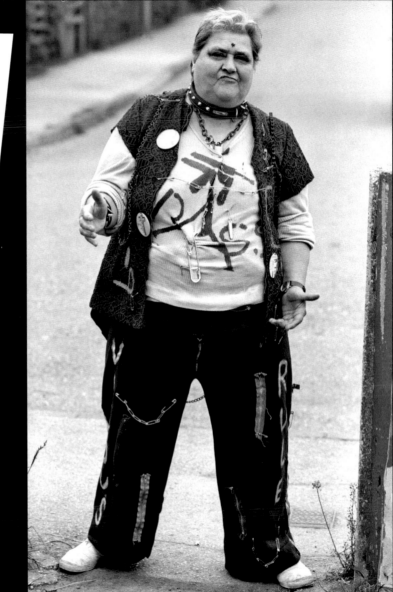

Act of charity
Grandmother Lil Bone dressed as a punk to raise money for charity.
12th July, 1980

Post-Pistols
Malcolm McLaren, after his time as manager of the Sex Pistols, displays sartorial elegance.
13th August, 1985

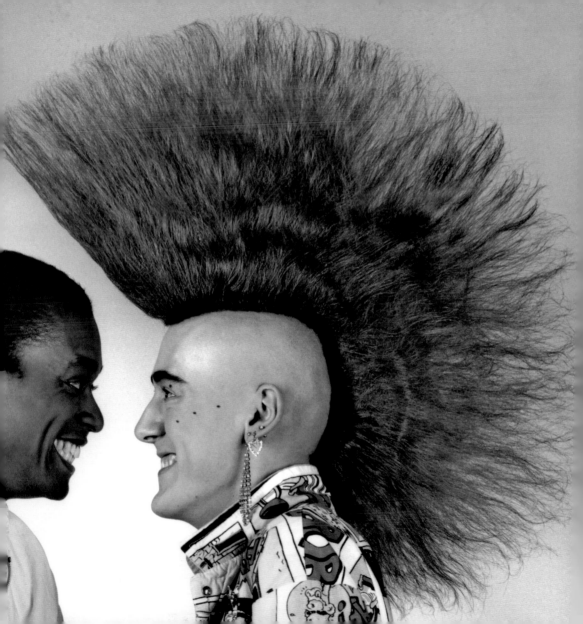

Mohican max
Left: Rebecca Malpass
eyeball-to-eyeball with punk
model Matt Belgrano.
19th December, 1986

I'll show you mine...
Punks Wendy Darlow and
boyfriend Martyn Hawden
compare hairstyles.
9th April, 1985

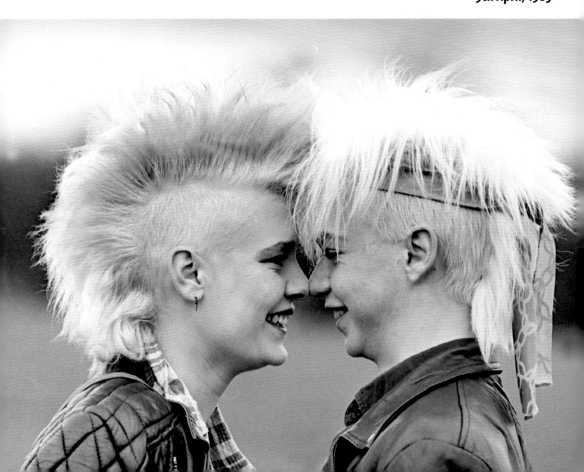

Beasties
Left: Although they came
to prominence as a hip-hop
band, America's Beastie Boys
started out as a hardcore pun
band in 1981.
1983

Glam drummer
Right: Ray Mayhew, drumme
and vocalist with the glam
punk band Sigue Sigue
Sputnik, which had been
formed by bassist Tony James
previously with Generation X
1984

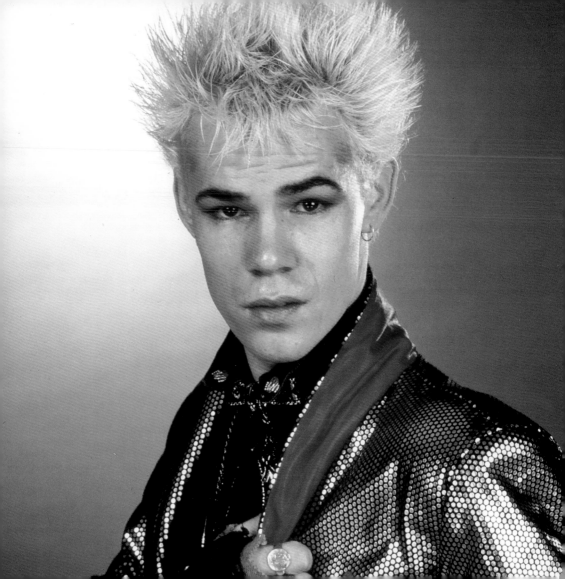

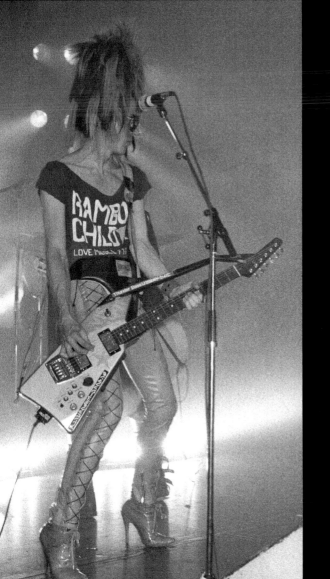

Heading for orbit
Glam punk band Sigue Sigue Sputnik in concert. The band had been formed by former Generation X bassist Tony James (L) and included Neal X (R).
28th February, 1986

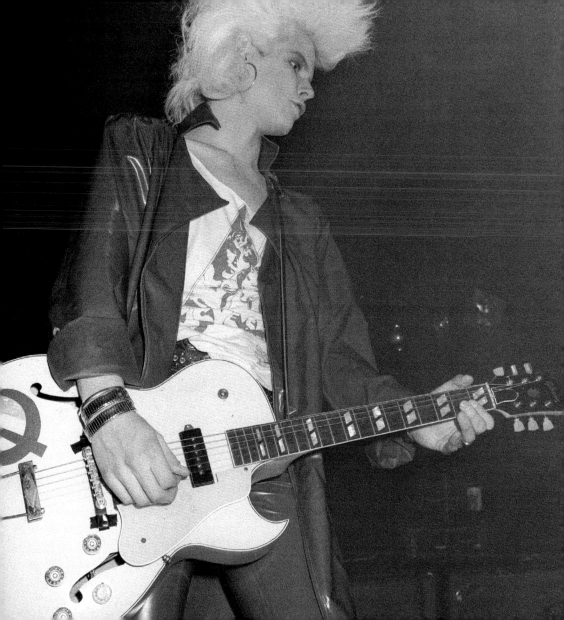

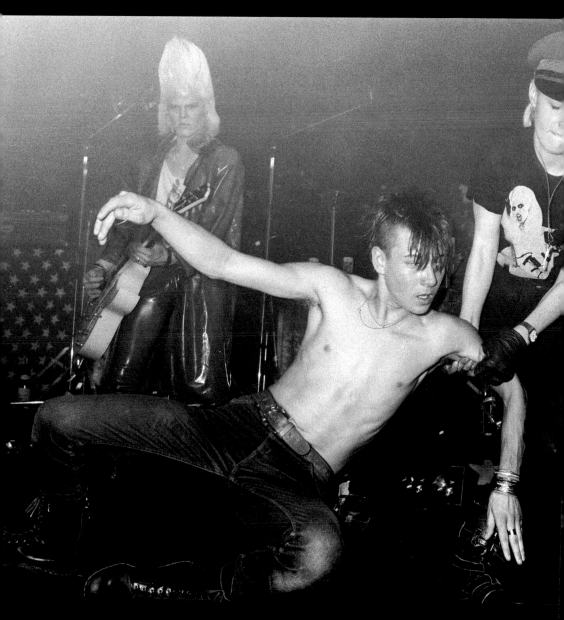

Spaced-out odyssey
A dazed looking fan is
helped from the stage
by Sigue Sigue Sputnik
keyboard player Yana
(L), while vocalist Martin
Degville lets rip (below).
28th February, 1986

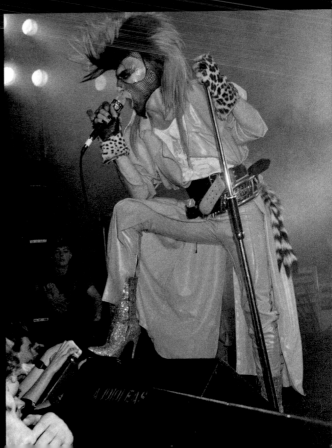

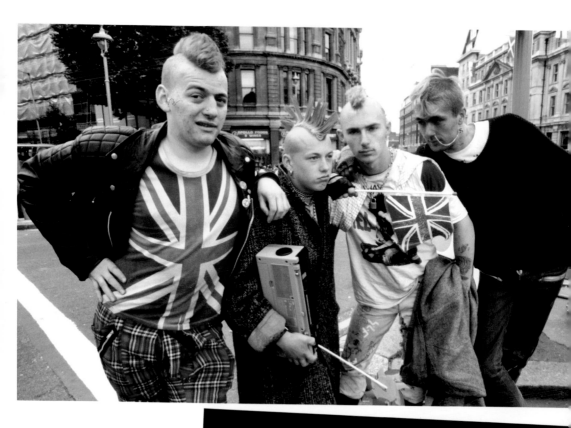

Punk patriots
A group of punks show a variety of Mohican hairstyles and demonstrate their patriotic feelings.
23rd July, 1986

Tribute band
Right: The Scottish Sex Pistols, who released an album in 1983 titled *Never Mind The Trossachs Here's The Scottish Sex Pistols*.
1983

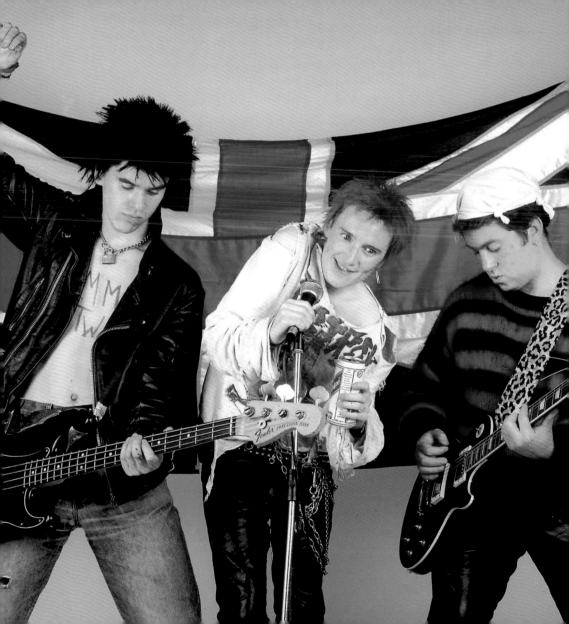

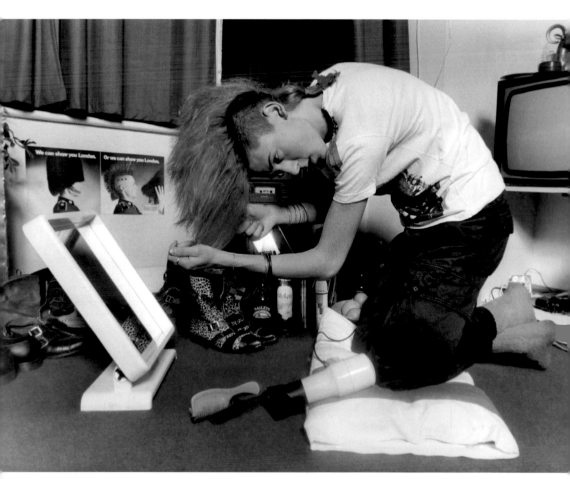

Keeping up appearances
Punk model Matt Belgrano gets to work on his hair, before a photo shoot at Big Ben in London.
April, 1986

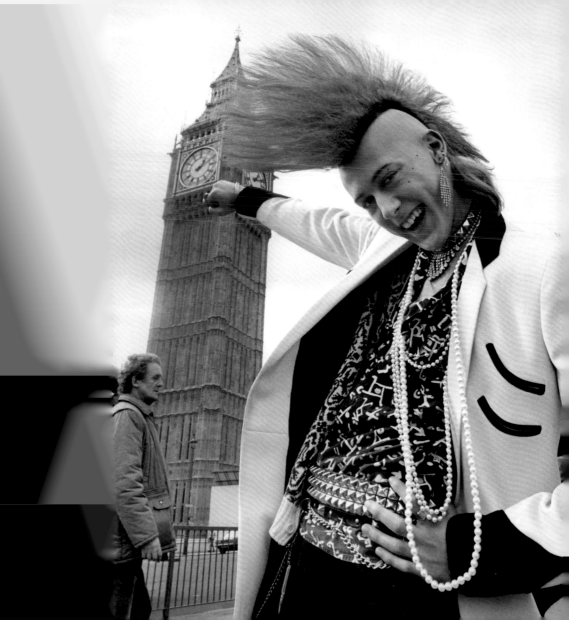

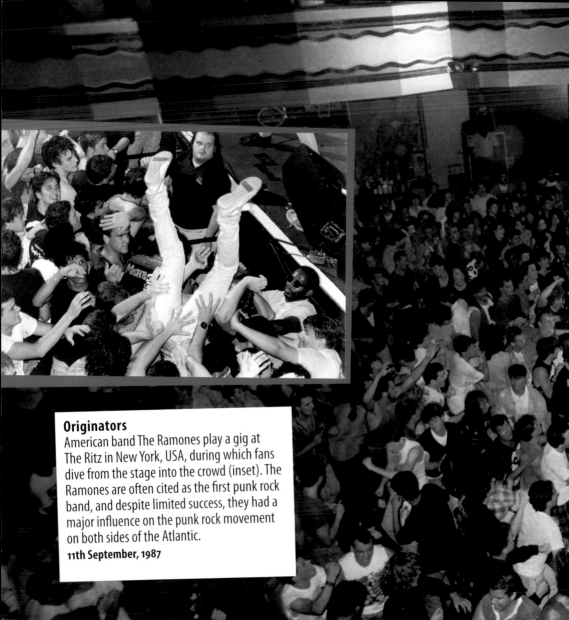

Originators
American band The Ramones play a gig at The Ritz in New York, USA, during which fans dive from the stage into the crowd (inset). The Ramones are often cited as the first punk rock band, and despite limited success, they had a major influence on the punk rock movement on both sides of the Atlantic.
11th September, 1987

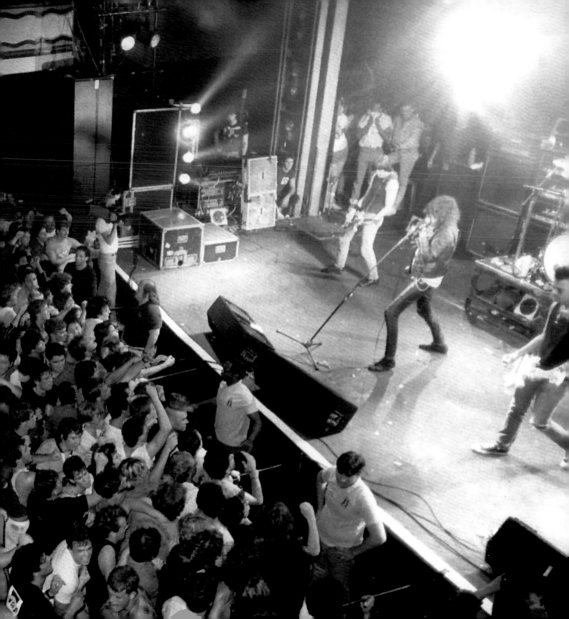

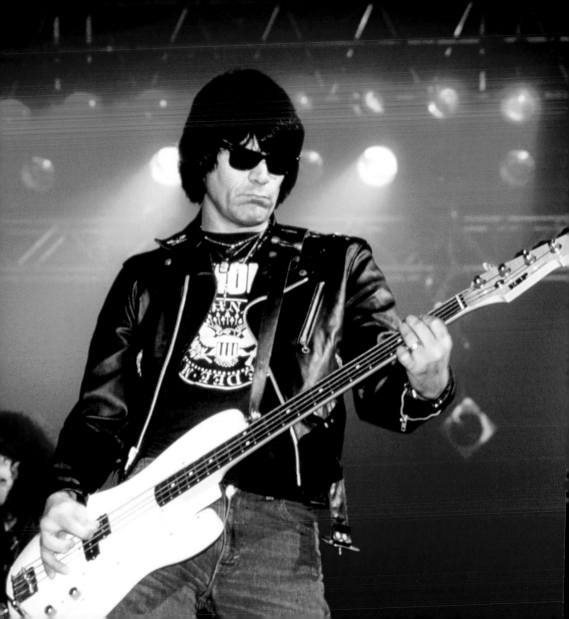

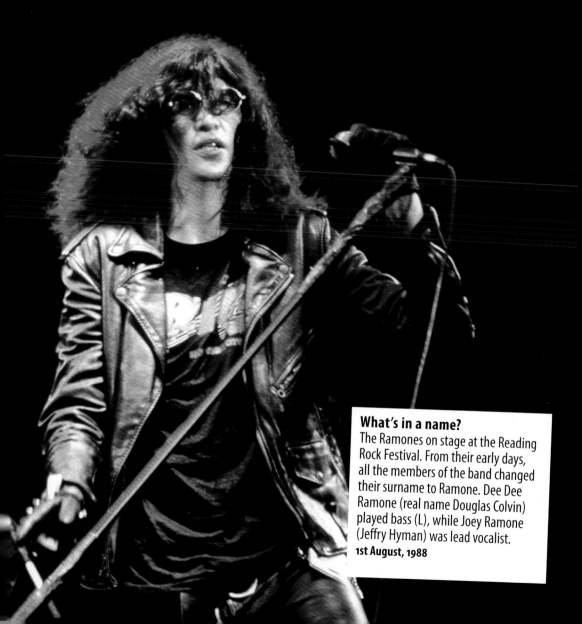

What's in a name?
The Ramones on stage at the Reading Rock Festival. From their early days, all the members of the band changed their surname to Ramone. Dee Dee Ramone (real name Douglas Colvin) played bass (L), while Joey Ramone (Jeffry Hyman) was lead vocalist.
1st August, 1988

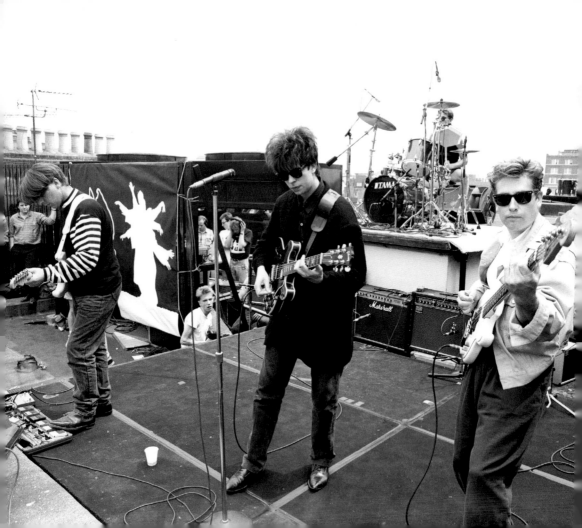

Rooftop gig

Left: Echo and The Bunnymen, a post-punk band, play a gig on a London rooftop. Post-punk bands, with their roots in punk, produced a sound that was less pop orientated than that of New Wave bands.

6th July, 1987

Demonstrator

Right: Singer/songwriter Billy Bragg at an anti-Gulf War demonstration with Labour politician Ken Livingstone (behind). A left-wing activist, Bragg was the most successful proponent of folk punk with a string of hits during the 1980s.

21st January, 1991

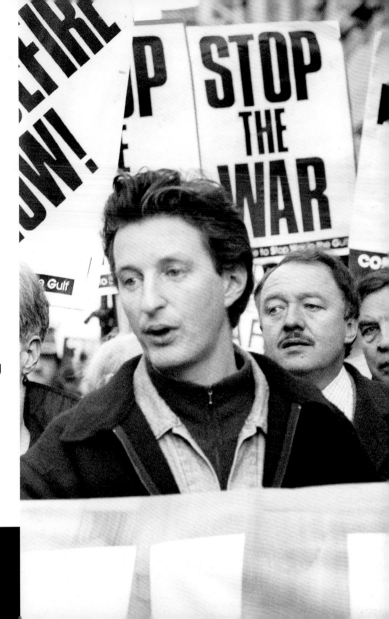

Youthful expression

Well-known actress and model Elizabeth Hurley was a punk in her late teens and dressed the part. She also dyed her hair pink.
1984

Rotten wife
John Lydon and
wife Nora, a
publishing heiress
from Germany.
**24th September,
1989**

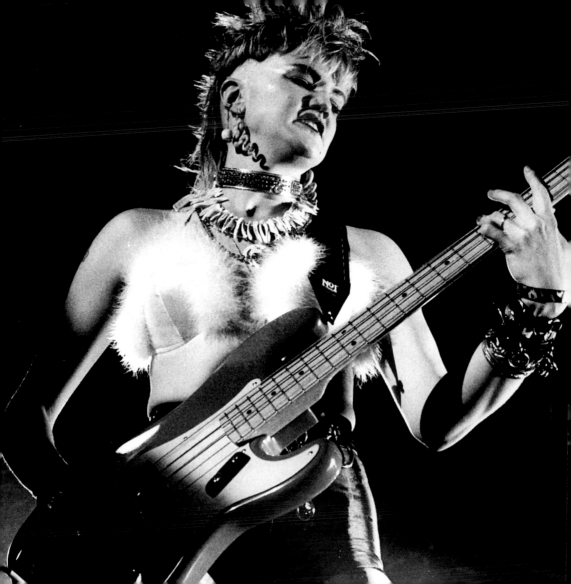

Short contract
Left: Fur (real name Jennifer Dixon), bass player with The Cramps. She remained with the band for only two months while on a world tour.
20th April, 1986

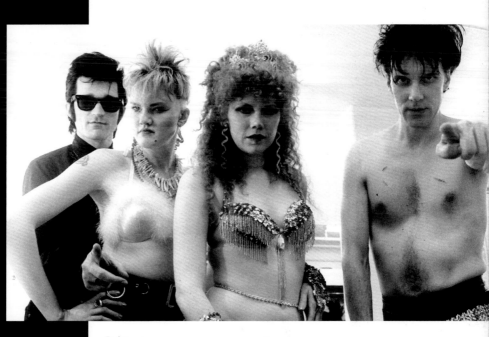

Prime movers
American band The Cramps: (L–R) Nick Knox, Fur, Poison Ivy, Lux Interior. Poison Ivy (real name Kristy Wallace) and Lux Interior were husband and wife, and they were the founding members of the band. One of the first garage punk bands, The Cramps were among the prime innovators of the psychobilly genre and also inspired many goth rock bands.
20th April, 1986

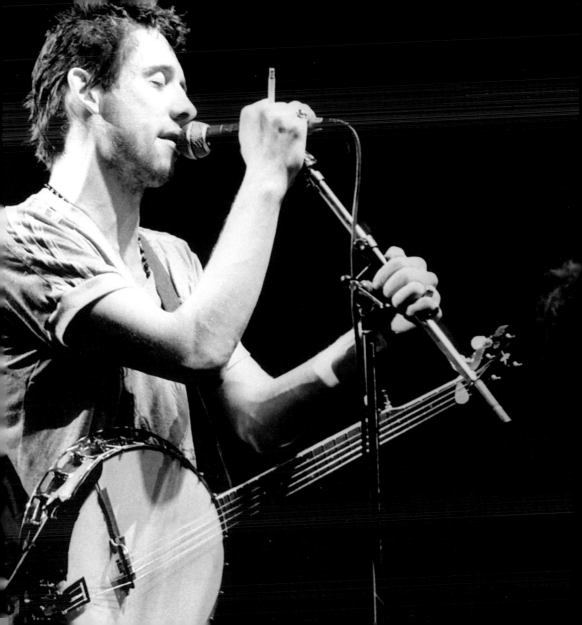

Irish pioneers

Left: Shane MacGowan of The Pogues, an Irish band that pioneered folk punk, a fusion of traditional folk music with punk rock. In 1987, they had a UK No. 2 single with *Fairytale of New York*, a collaboration with Kirsty McColl (background).

11th March, 1988

Damned David

Above: David Vanian, vocalist with The Damned.

1st June, 1988

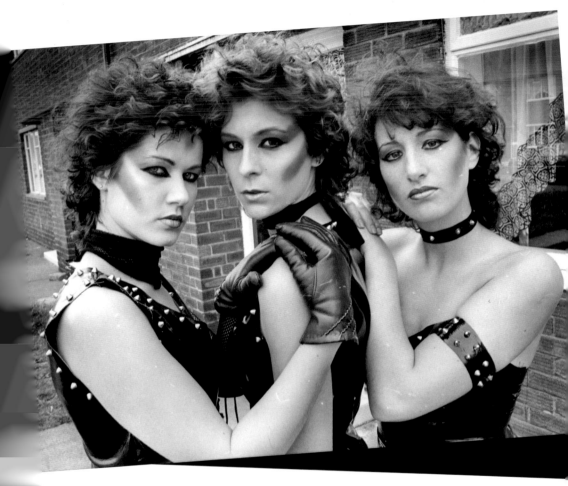

Explosive combination
Punk styles even entered the mainstream. Dance trio TNT adopted fetish gear and vivid make-up.
1980

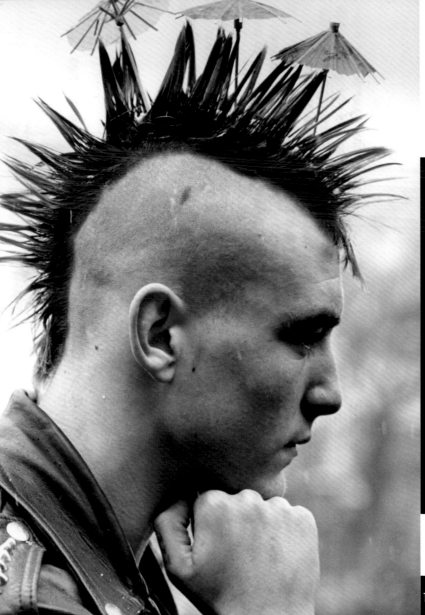

Brolly head
Mike 'The Spike' Lang added a twist to his Mohican haircut with tiny cocktail umbrellas.
4th March, 1981

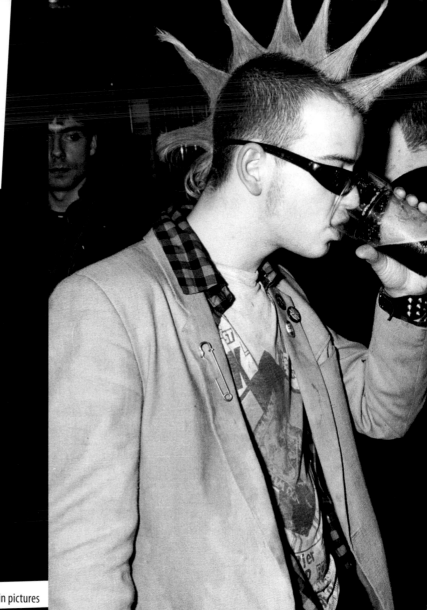

Drink up or I shoot!
A punk with a striking
Mohican hairstyle fools
around with a child's
cap pistol, while her
companion concentrates
on finishing his beer.
15th January, 1988

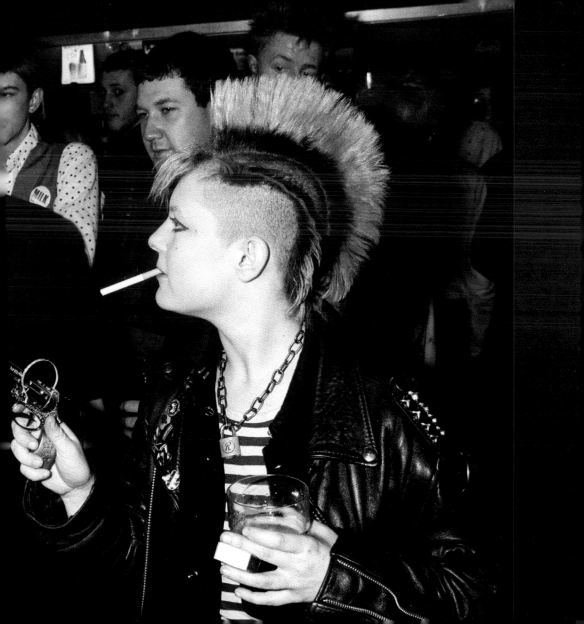

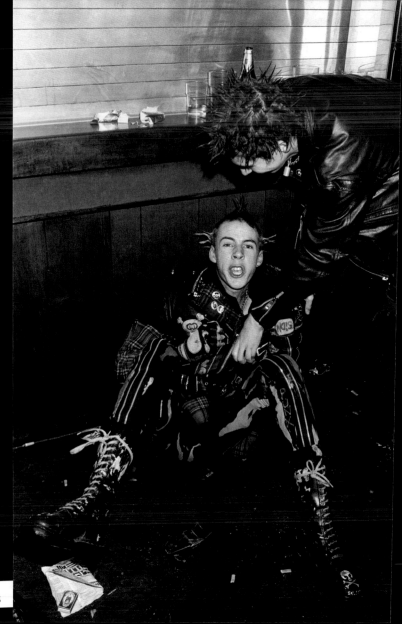

One too many?
Right: While his companion tries to help him to his feet, this punk vents his anger on the photographer.
15th January, 1988

Extension pieces
Far right: A Mohican with side wings.
15th January, 1988

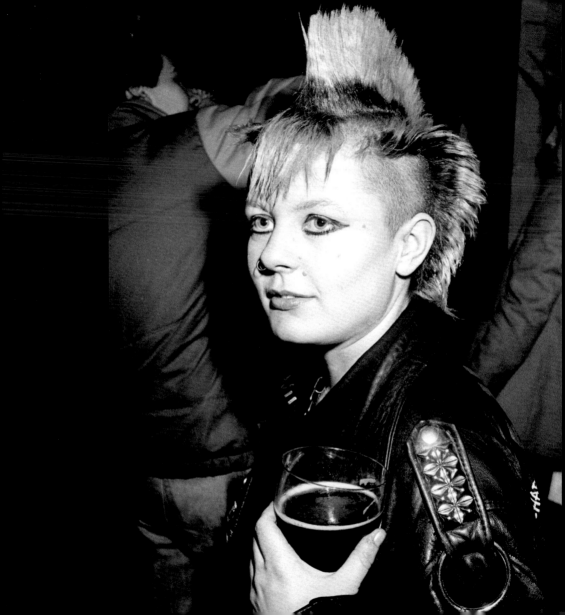

Earnest discussion

The floor is as good as anywhere to hold a conversation. The girls in this group show a propensity for fetish boots; fishnet tights were also a staple of punk female fashion.

15th January, 1988

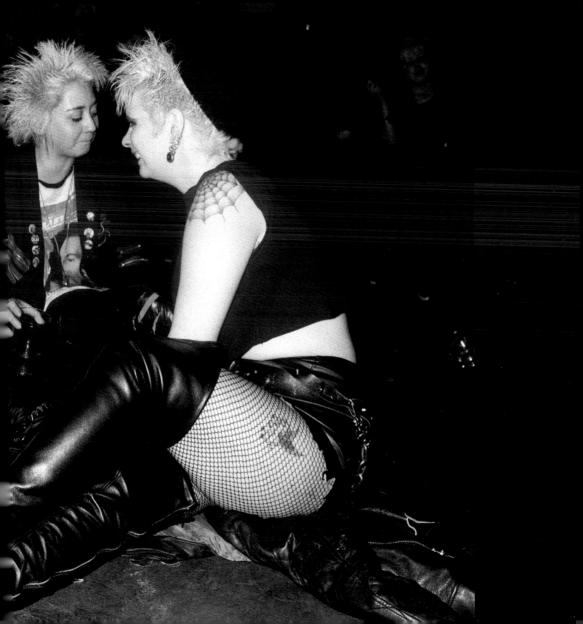

Haircut 100

A punk at the 100 Club on Oxford Street, London to commemorate the tenth anniversary of the final Sex Pistols concert in San Francisco in 1978.

15th January, 1988

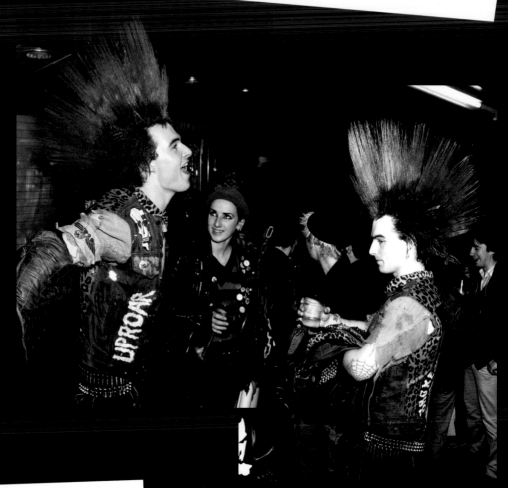

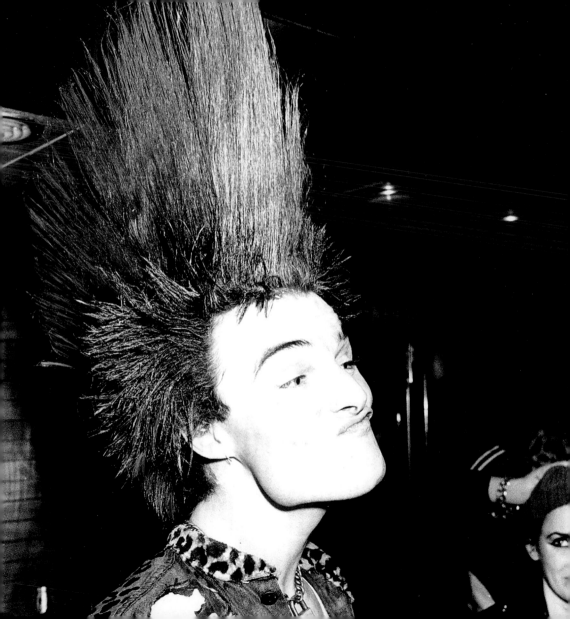

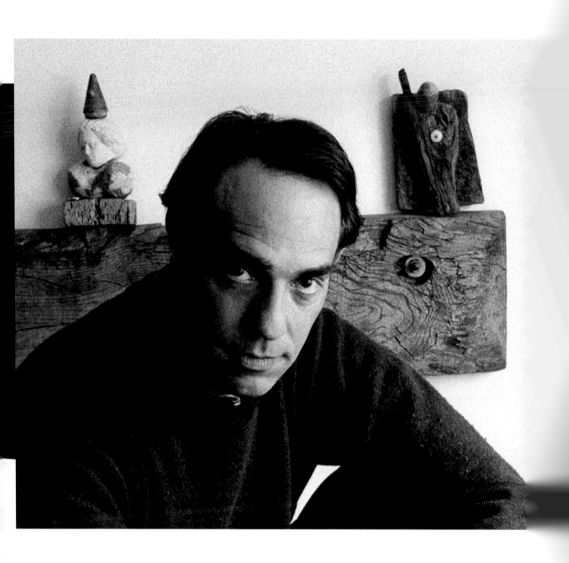

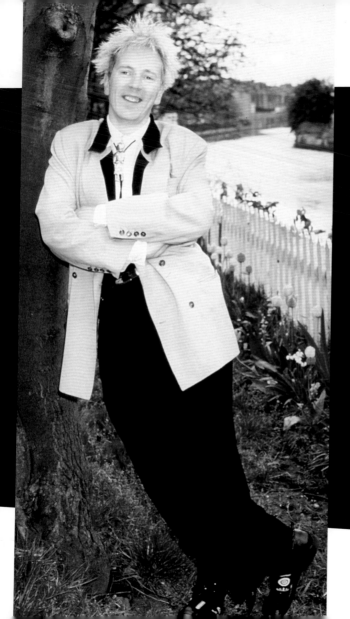

Film maker
Facing page: Derek Jarman, English film director, who was responsible for the UK's first punk movie, *Jubilee*, released in 1978, which many regard as his first masterpiece. It featured many punk groups and figures, including Wayne County, Toyah Willcox, Jordan, and Adam and The Ants.
24th March, 1988.

Smiling Rotten
Left: John Lydon contemplates the release of his band Public Image Ltd's latest album, *9*.
1989

Record sale

American band The Ramones at the Oxford Street, London HMV Music Store to promote their first compilation album, *Ramones Mania*. Photo right shows (L–R) Johnny Ramone, Joey Ramone and Dee Dee Ramone.

18th June, 1988

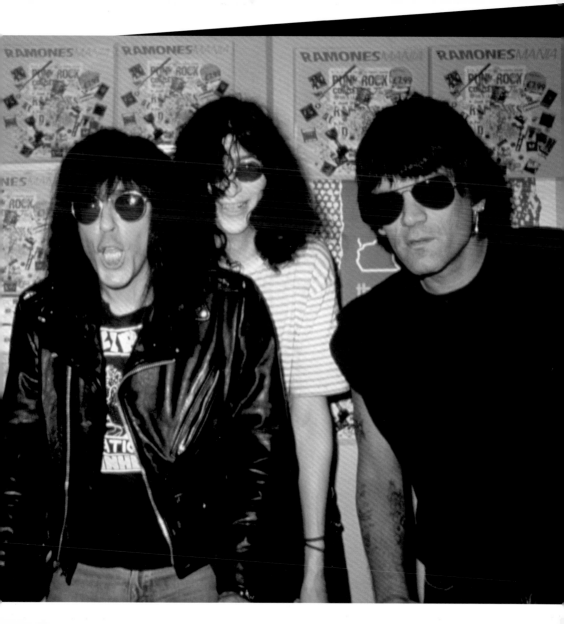

Men in black
The Stranglers, minus founding member Hugh Cornwell, who had left to pursue a solo career. L–R: Jean-Jacques Burnel, Paul Roberts, Jet Black, Dave Greenfield, John Ellis.
10th January, 1991

Singing cure
Right: Robert Smith, lead singer of post-punk/New Wave band The Cure. Since the band's inception in 1976, Smith has been the sole constant member.
23rd April, 1992

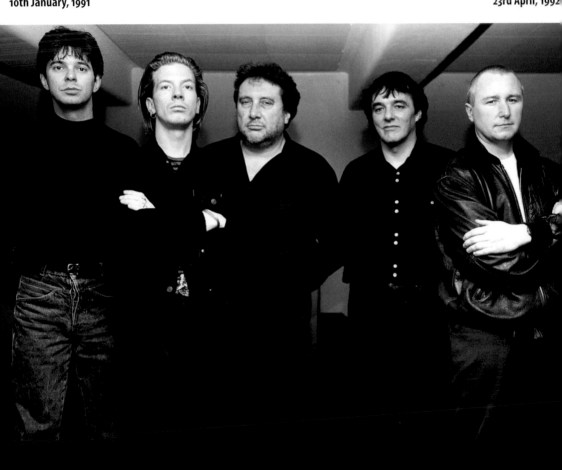

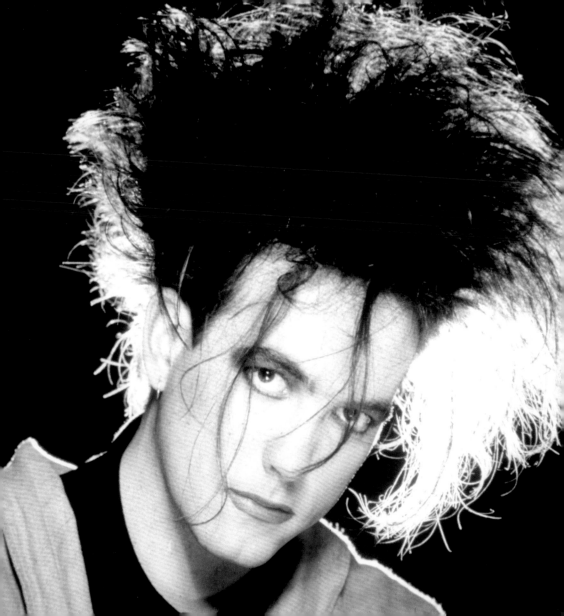

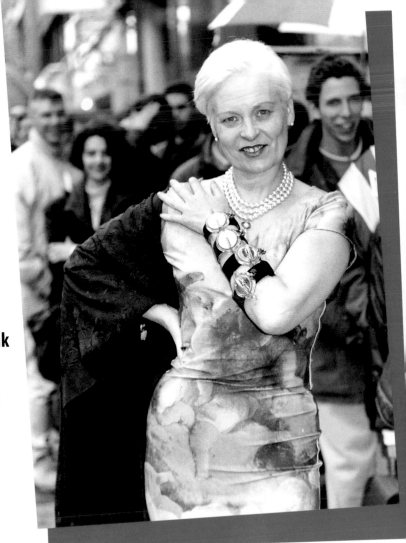

A long way from punk
Vivienne Westwood,
award winning fashion
designer, at the Swatch
shop in Oxford Street,
London, to launch her
watch, The Orb.
18th April, 1993

Acting the part
Toyah Willcox, now an established actress, would play the part of Miss Scarlett in a television *Cluedo* programme to be screened on Boxing Day, 1990.
29th November, 1990

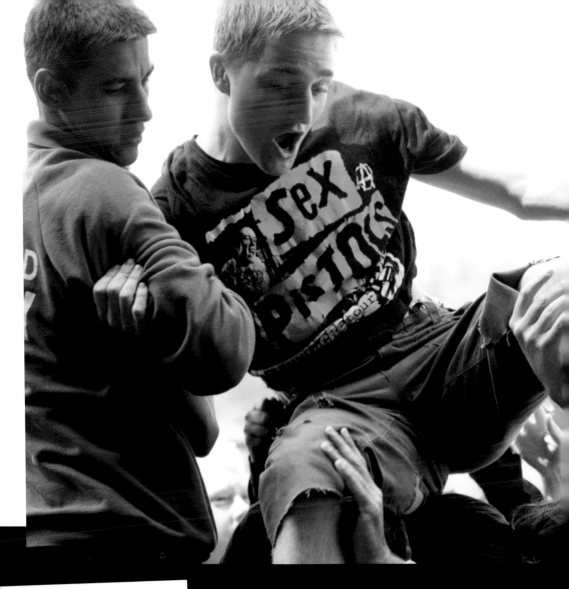

Pistols in the park

A fan tussles with security men during a gig by the re-formed Sex Pistols at Finsbury Park, London, part of their Filthy Lucre Tour. **23rd June, 1996**

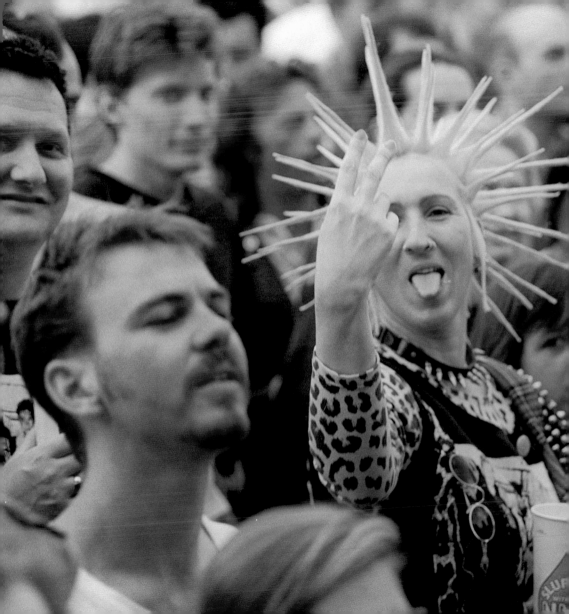

Saluted
A punk at the Sex Pistols gig in Finsbury Park, London shows her appreciation of the camera.
23rd June, 1996

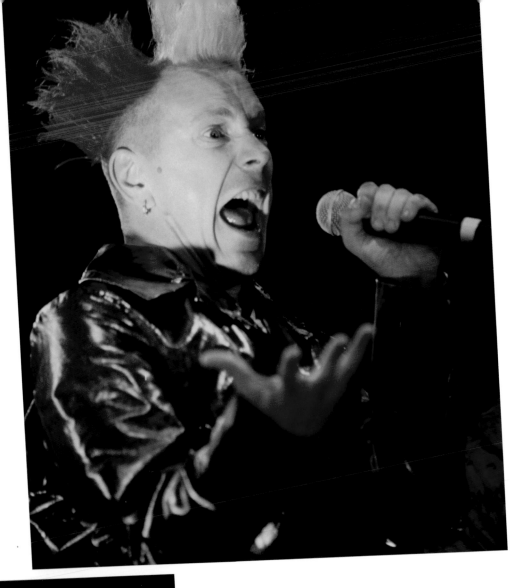

Hairstyles

Johnny Rotten (John Lydon) displays two distinctly different styles of coiffure during the re-formed Sex Pistols' Filthy Lucre Tour. The Phoenix Festival at Long Marston Airfield, near Stratford-upon-Avon, saw the red and yellow number (L), while fans at Finsbury Park, London, were treated to the pale blue spikes.

1996

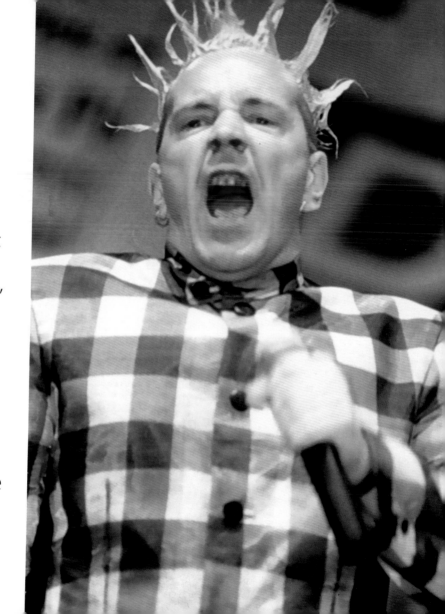

Oi!, Oi!
Left: Mensi (real name Thomas Mensforth), vocalist with the punk/Oi! band Angelic Upstarts, behind the bar of his own country pub.
1990

Police doctor
Right: Sting receives an honorary doctorate of music from the University of Northumbria.
13th November, 1992

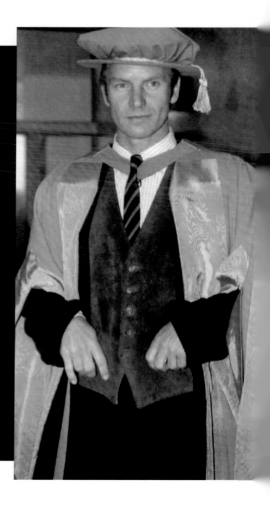

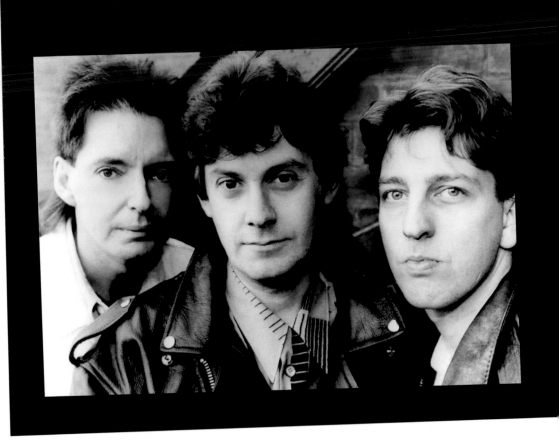

Three stiffs
Irish punk band Stiff Little Fingers in their later years: (L–R) Bruce Foxton (bass),
Jake Burns (vocals), Dolphin Taylor (drums).

1994

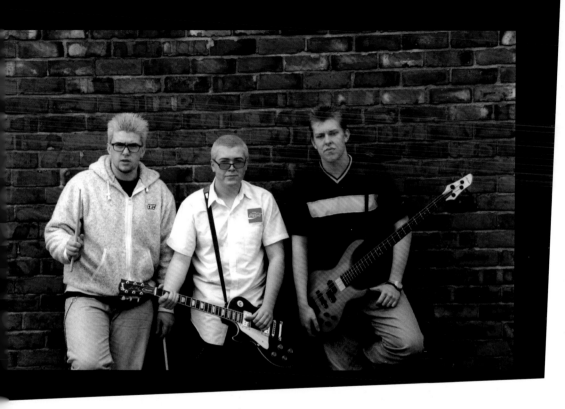

Blood brothers
Punk band Bleed: (L–R) Andrew Duncan (drums), Greg Robson (guitar), Mark Watson (bass).
11th June, 1998

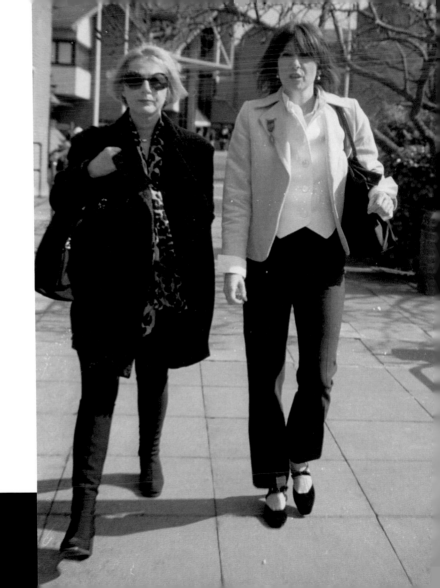

Knife charge

Chrissie Hynde (R) at Uxbridge Magistrates' Court, where she appeared on a charge of attempting to board a plane at Heathrow carrying a banned knife. She was acquitted.

21st March, 1997

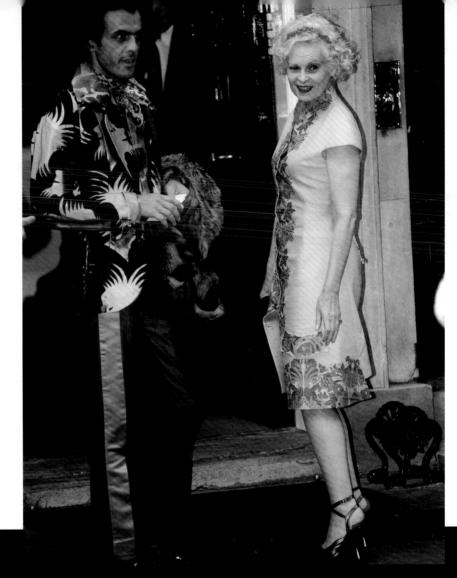

Part of the Establishment
Right: Vivienne Westwood at 10 Downing Street for a party held by Prime Minister Tony Blair.
30th July, 1997

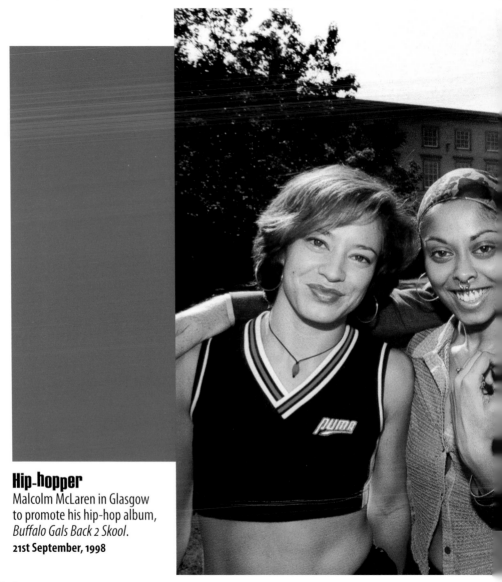

Hip-hopper
Malcolm McLaren in Glasgow to promote his hip-hop album, *Buffalo Gals Back 2 Skool*.
21st September, 1998

Czech mates

The Sex Pistols while on tour in Prague, Czech Republic.

9th July, 1996

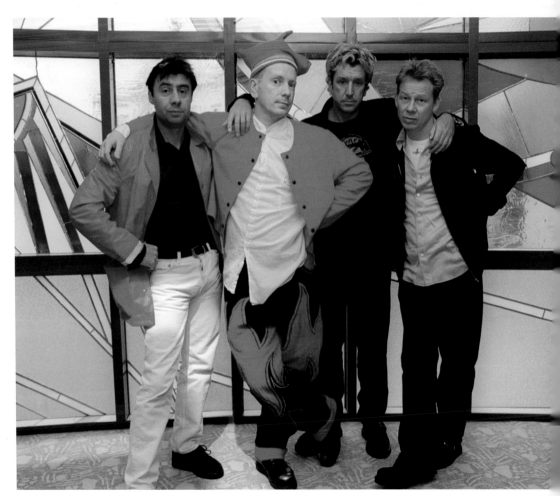

Punk! The culture in pictures

Buzzers
English punk band China Drum riding their buzzboards, which attracted the displeasure of the police. L–R: Jan Alkema, Dave McQueen, Adam Lee, Bill McQueen. The band was active between 1989 and 2001.
29th May, 1997

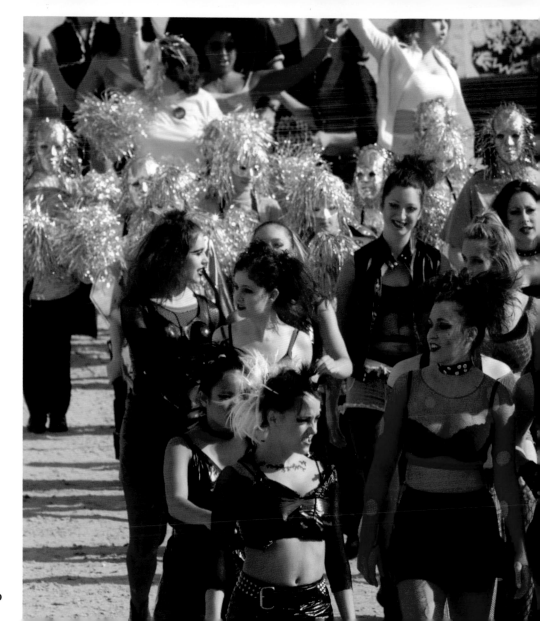

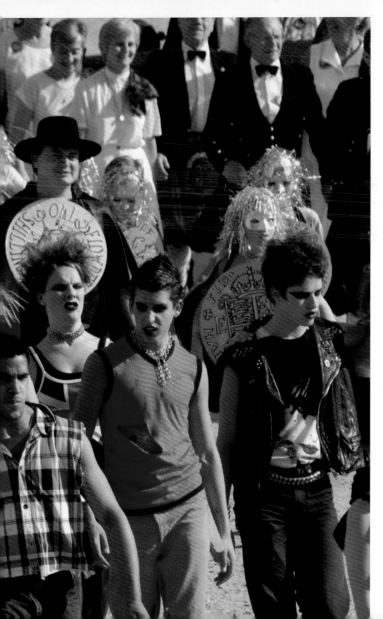

Punks on parade
A national celebration of Queen Elizabeth the Queen Mother's 100th birthday included a pageant that took place on Horse Guards Parade, London, and that featured a group of punks.
19th July, 2000

Passage of time
The Sex Pistols showing their age.
6th July, 2002

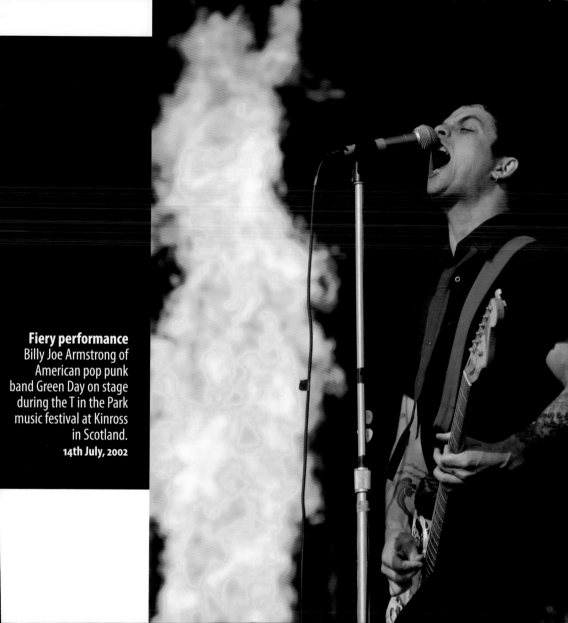

Fiery performance
Billy Joe Armstrong of
American pop punk
band Green Day on stage
during the T in the Park
music festival at Kinross
in Scotland.
14th July, 2002

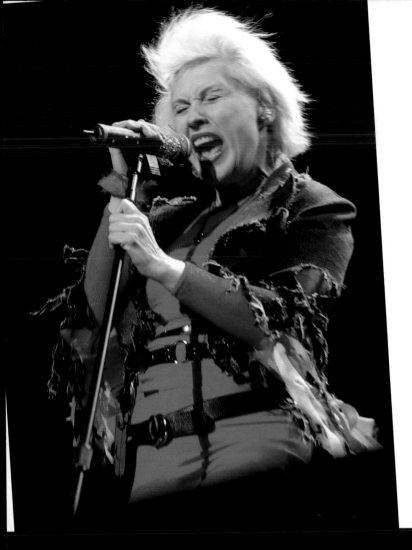

On the waterfront
Left: Debbie Harry in concert with a re-formed Blondie at the Waterfront Hall, Belfast.
10th November, 2003

Rotten angry
Right: John Lydon vents his ire on the photographer during a boat trip at Surfers Paradise, Queensland. Lydon was in Australia for the making of the TV programme *I'm a Celebrity... Get Me Out of Here!*
7th February, 2004

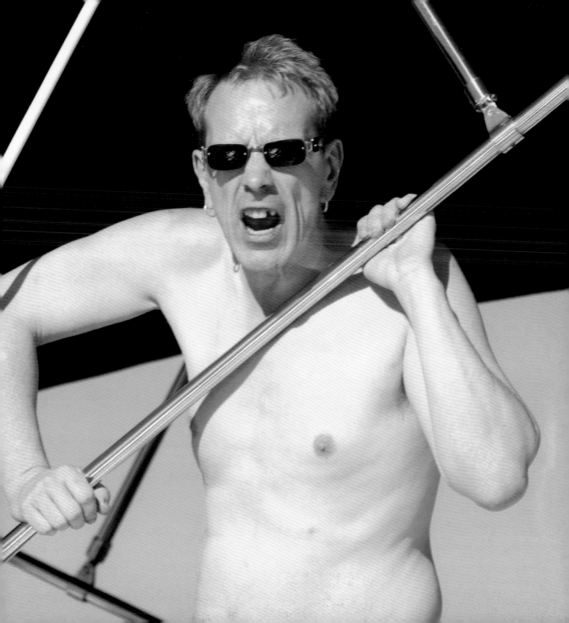

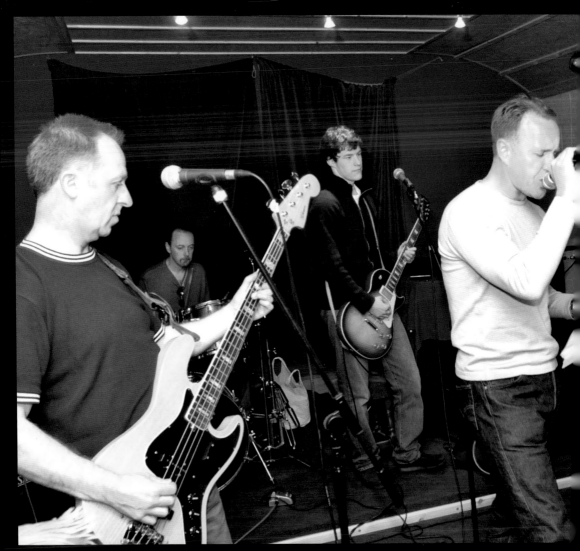

Getting it back together
The re-united Skids rehearse in a recording studio.
4th May, 2002

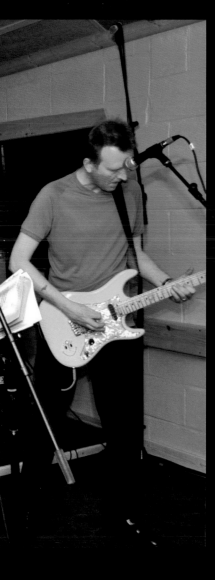

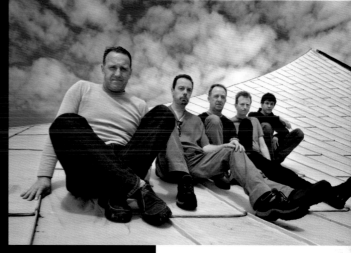

Sitting the roof
Skids take time out to
pose on the roof of the
recording studio.
4th May, 2002

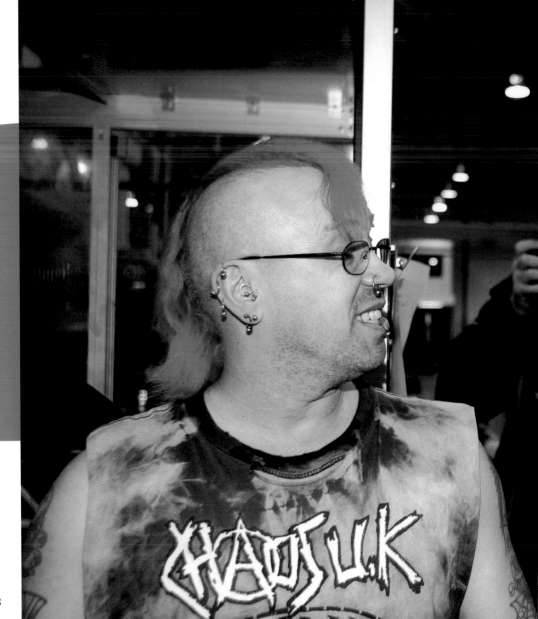

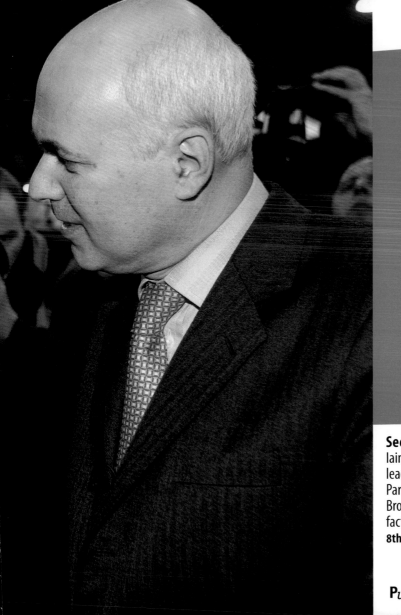

Seeing pink
Iain Duncan Smith, at the time
leader of the Conservative
Party, chats with punk Nicholas
Brooke during a visit to a
factory in Blackpool, Lancashire.
8th October, 2003

Punk pastiche
A modern fashion editor's take on punk style: not quite the shock tactics employed by real punks.
22nd October, 2003

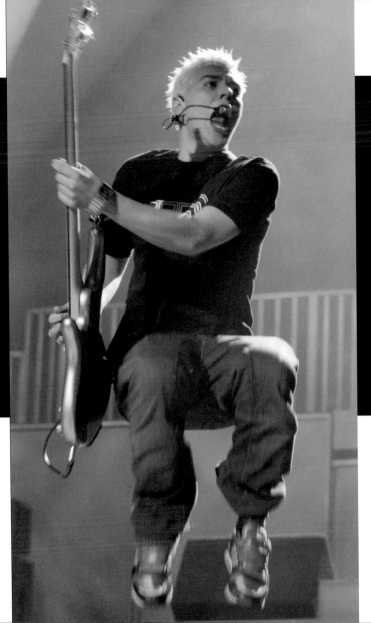

Jumping James
Left: James Bourne of pop
punk band Busted, on stage
during the Pepsi Silver Clef
Concert in Manchester.
14th May, 2003

In the mainstream
Right: Tom Fletcher on stage
in Newcastle with pop punk
band McFly. Pop punk bands
have brought punk into the
mainstream by combining
elements of the genre with
pop music.
27th March, 2011

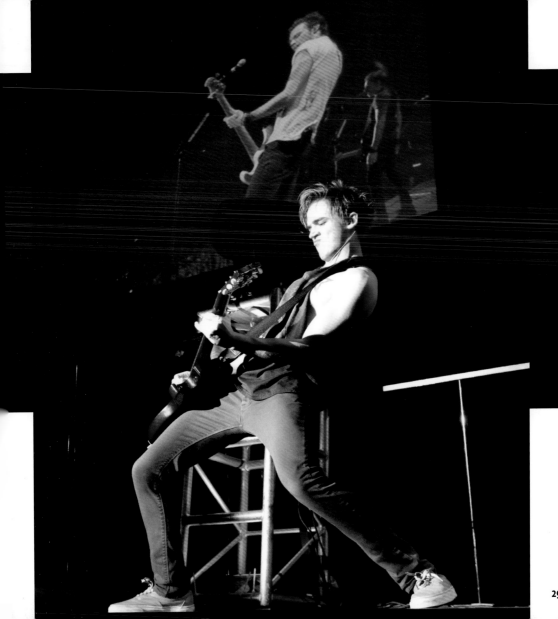

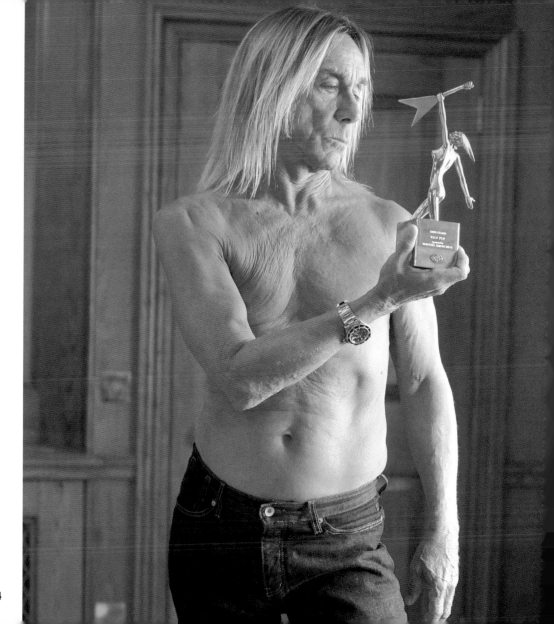

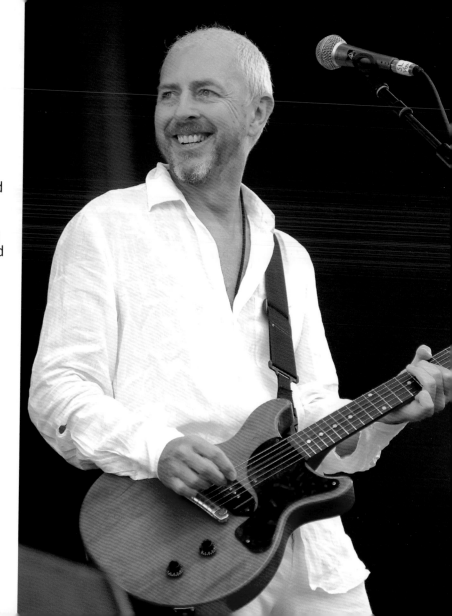

Poptastic
Left: Often characterised as the 'Godfather of punk', Iggy Pop contemplates the Living Legend Award presented to him by Classic Rock magazine.
1st November, 2009

Punk legends
Right: Tony James, formerly of Generation X and Sigue Sigue Sputnik, on stage at the Isle of White Festival as part of Carbon/Silicon, a rock duo he formed with ex-Clash guitarist Mick Jones.
2007

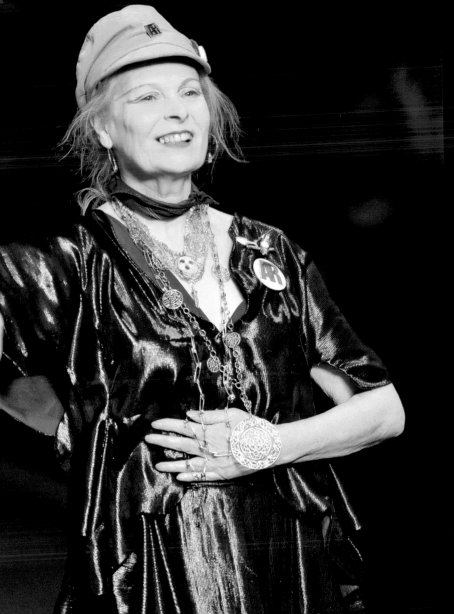

Fashion icon
Left: Vivienne Westwood accepts the applause for her Red Label Spring/Summer Collection during London Fashion Week.
September, 2008

Rotten teeth
Right: John Lydon hams it up for the camera, although the state of his teeth was the reason for his stage name, Johnny Rotten. In 2008, he would undergo dental work in the USA costing around $22,000.
17th July, 2002

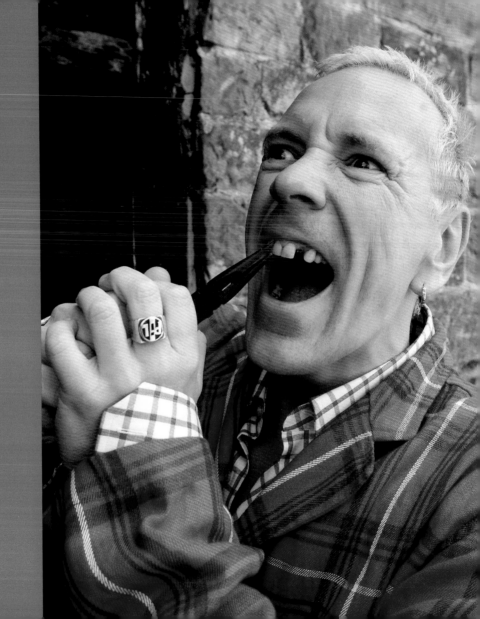

Reformed character
John Lydon encourages the crowd while on stage with the re-formed Sex Pistols at the Isle of Wight Festival.
2008

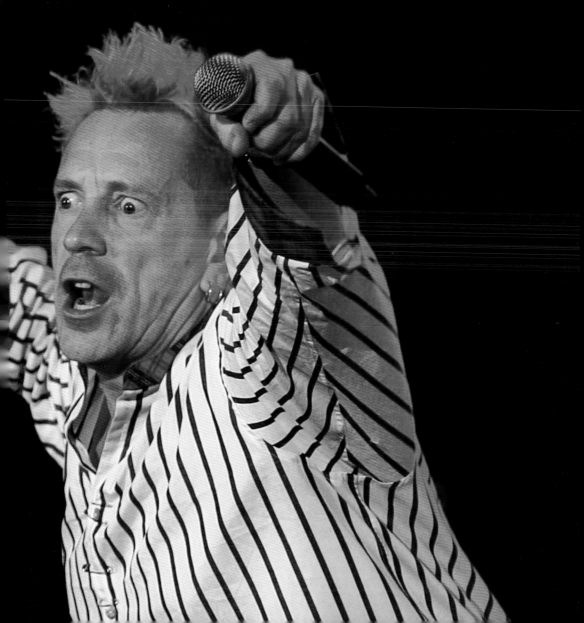

The publishers gratefully acknowledge Mirrorpix, from whose extensive archives
the photographs in this book have been selected.

AMMONITE
PRESS